EXTENDING The Artist's Hand

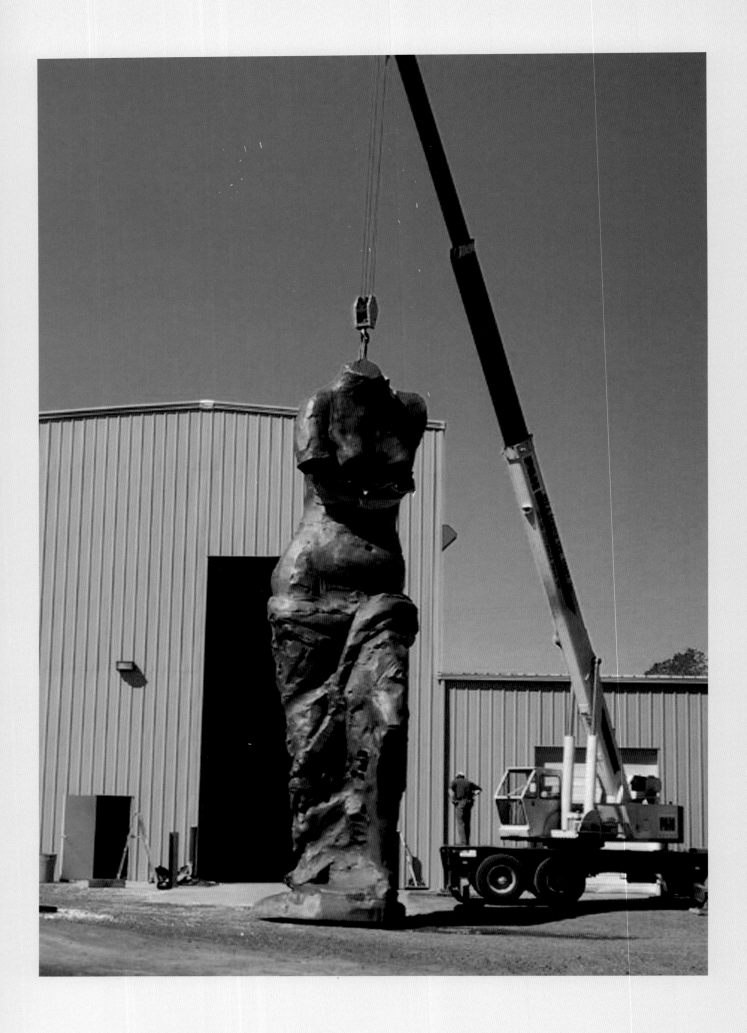

Mark Anderson

Chris Bruce

Keith Wells

with an essay by

Jim Dine

EXTENDING The Artist's Hand

CONTEMPORARY SCULPTURE FROM THE
Walla Walla Foundry

Museum of Art

Washington State University

Pullman, Washington

This publication was produced in conjunction with two exhibitions:

Jim Dine: Sculpture from Walla Walla Foundry
August 20–October 17, 2004
Museum of Art / Washington State University

Sculpture from the Walla Walla Foundry
August 20–November 1, 2004
Washington State University

Library of Congress Control Number: 2004108555
ISBN: 0-9755662-0-2

Front cover details, left to right: Deborah Butterfield, *Untitled*, 2004;
Ed Kienholz and Nancy Reddin Kienholz, *Mine Camp*, 1991; Jim Dine,
The Field of the Cloth of Gold, 1987–88
Back cover: Walla Walla Foundry before restoration
Page 1: Bill Will working on *Everyday Hero*
Page 2: Jim Dine's *Cleveland Venus* leaving the Walla Walla Foundry
Page 3: Jim Dine, *Looking Toward the Avenue*, 1989
Page 7: Washington State University campus
Page 112: Bill Will, *Everyday Hero*, 1997

Edited by Michelle Piranio
Designed by John Hubbard
Color separations by iocolor, Seattle
Produced by Marquand Books, Inc., Seattle
 www.marquand.com
Printed and bound by CS Graphics Pte., Ltd., Singapore

DONORS

The Allen Foundation for the Arts

Jon and Mary Shirley Foundation

Pullman Community Foundation, an affiliate
 of Foundation Northwest

Judith and J. Cleve Borth

Donald and Sylvia Bushaw

Robert P. and Ruth E. Gibb

Duff and Dorothy Kennedy

Scott and Betty Lukins

Timothy A. Manring

Virginia Leigh Neill

Robert and Winona Nilan

Jim and Kelma Short

Nancy and Paul Winklesky

H. S. Wright III

An Anonymous Donor in Honor of Lane and
 Mary Jo Rawlins

Friends of the Museum of Art

THE ALLEN FOUNDATION *for* THE ARTS

CONTENTS

FOREWORD AND ACKNOWLEDGMENTS

This very special project brings together for the first time two of the most important art institutions in the Inland Northwest: the Walla Walla Foundry as maker and the Museum of Art at Washington State University as presenter. It is a fitting representation of the Museum's mission to provide our audiences with world-class examples of innovation and creativity, and also serves to celebrate the Museum's thirtieth anniversary.

As regional neighbors, Washington State University and the Walla Walla Foundry share the proposition that exceptional accomplishments, significant organizations, and great art can be created and appreciated in our largely rural setting.

Founded in 1980 by Mark Anderson in a small garage/repair shop, the Walla Walla Foundry has gone on to become one of the most important and active contemporary art bronze-casting facilities in the United States. The foundry's excellence was recognized in 1996 when it was honored with the Governor's Arts Award, and its stature has grown consistently ever since. Still, it remains largely unknown to the general art audience—due in part to its relatively isolated location in eastern Washington, but also because it plays out its vital role behind the scenes. It is our hope that this book increases both awareness of and appreciation for this special place.

The overall project includes a series of outdoor installations, on Washington State University's Pullman campus, of sculptures by various artists who have worked at the foundry as well as a major museum survey of works by internationally renowned artist Jim Dine, made at Walla Walla between 1983 and 2004. Dine's work was chosen as a focus for the exhibition because he has used the foundry more than any other artist. This two-decade collaboration has been a stimulus for the remarkable development of the artist's sculptural practice since 1983, and has also been an inspiration for the foundry's own evolution.

The idea for an exhibition focusing on the Walla Walla Foundry originated with Keith Wells, Museum of Art curator. Chris Bruce, director of the Museum, was new to WSU, but he was well aware of the foundry's accomplishments and is a longtime friend of Dine's. The idea fit perfectly with Chris's focus on "Northwest cultural resources of national and international distinction," be they collectors, artists, or institutions. We are grateful for Chris's vision and leadership, which have raised the bar of the Museum's potential to contribute to WSU's mission of excellence and to the cultural landscape of this region.

A project of this scope requires a great deal of commitment and collaboration, and I join Chris in acknowledging our many generous partners. At the Walla Walla Foundry, Mark and Patty Anderson graciously opened their home and archives for the project and were invaluable in arranging transport and installation of the impressive works of art in the exhibition. Susan Dunne, director of PaceWildenstein Gallery in New York, with the help of Emily-Jane Kirwan, provided crucial assistance in arranging all aspects related to the presentation of Dine's work. The Alturas Foundation generously agreed to loan the Tom Otterness sculptures *Makin' Hay*. Marquand Books in Seattle oversaw the production

of this handsome publication, and we acknowledge the unstinting efforts of project manager John Trombold, designer John Hubbard, and independent editor Michelle Piranio. At the Museum of Art, special thanks goes to Rob Snyder, director of development, who raises funds for all museum programs with dignified and enthusiastic stewardship, to assistant director Anna Maria Shannon, who exactingly attends to all details, large and small, and to curator Keith Wells, who handled all aspects of the exhibitions.

We are especially grateful to Paul Allen and Jody Patton of the Allen Foundation for the Arts for their major support, which came at a key, early phase in the development of the project. Additional funding is provided by the Jon and Mary Shirley Foundation, Pullman Community Foundation, and by significant donations from the WSU community: Judy and Cleve Borth, Don and Sylvia Bushaw, Bob and Ruth Gibb, Duff and Dorothy Kennedy, Scott and Betty Lukins, Tim Manring, Ginny Neill, Bob and Win Nilan, Jim and Kelma Short, Nancy and Paul Winklesky, and Howard Wright. The Museum's exhibition program is also supported by the Friends of the Museum of Art. Without the commitment and generous contributions of these individuals and organizations, this project would not have been possible.

I am delighted that this important exhibition coincides with the thirtieth anniversary of WSU's Museum of Art, and I am grateful to all of our donors for their support of this exceptional undertaking.

V. LANE RAWLINS
President, Washington State University

Chris Bruce

WALLA WALLA FOUNDRY
"AN EXTENSION OF THE ARTIST'S HANDS"

Walla Walla, Washington, is an Iowa of the mind—summers of well-manicured lawns, harvest falls, and winters of springtime preparation. Settled in the 1850s by pioneers who found a rich farmland at the base of the Blue Mountains, it harkens back to the way America always thought it could be. Some 250 miles from Seattle and about the same from Portland and Boise, it is pretty much on the way to nowhere, unless you're driving between, say, Pendleton, Oregon, and Lewiston, Idaho. Walla Walla is famous for sweet onions and fine wines; it is known for a maximum-security prison and for being a town so nice they named it twice. It is also home to an exceptional bronze-casting facility.

Not just a casting facility, but a serious fine art foundry. From its humble beginnings in 1980, the goal of the Walla Walla Foundry has been to "focus on assisting the artist who is creating contemporary art in metal by serving as expert technical support and encouraging experimentation."[1] This type of endeavor would make perfect sense near a major art center such as New York or San Francisco. But in the Inland Empire, as this area of the country is sometimes called, the town rodeo is generally the biggest event of the year; you are more likely to get your props by casting eagles that look like real eagles or table-top-sized horses (that look like real horses) than by casting the kind of work that comes out of Mark Anderson's foundry.

Anderson's commitment to fine craftsmanship and to expressive contemporary art has resulted in a unique series of ongoing collaborations between master technicians and such renowned artists as Jim Dine, Robert Arneson, Peter Shelton, Deborah Butterfield, Terry Allen, Lynda Benglis, Tom Otterness, Roy Lichtenstein, John Buck, Nancy Graves, David Bates, and Ed and Nancy Kienholz, among others. All of these artists came to Walla Walla for one reason: to have their artistic visions rendered in metal by experts of the highest caliber. Dine says flat out that "they're just the best foundry in America."[2]

The idea of a place that provides art production services is by no means unique to Walla Walla, although it may be among the more remote locations. As more and more artists have felt free to explore a wide variety of media, the need for technical support has become firmly established as part of the ecology of the art world. It is no coincidence that Dine is one of the foundry's primary users, for his generation of artists from the 1960s was among the most aggressive in terms of embracing various media and processes—and among the most ambitious in terms of pushing boundaries. These artists, generally identified with Pop art, experimented with methods and materials of all kinds; in the largest sense, they asserted the possibility that art could be *anything*, that nothing could be excluded from consideration. Robert Rauschenberg, Andy Warhol, Claes Oldenburg, and Dine, among others, moved fluidly from painting and drawing to sculpture, printmaking, assemblage, performance, film,

Tom Otterness, *Makin' Hay*, 2002, temporary installation at Utica, Montana

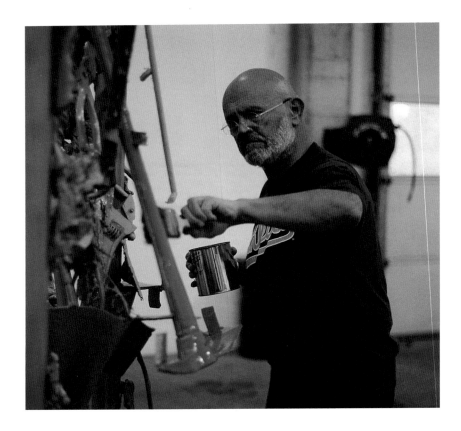

FIGURE 1 Jim Dine painting
Garden of Eden, 2003

and photography, as though each medium were another color on the artist's palette.

"Art and Technology" became a buzz phrase for the time, referring to anything that combined an artist's personal inspiration with a machine, be it a litho press, a movie camera, a sprinkler system (Warhol), or a pool of bubbling mud (Rauschenberg). And yet as expansive and inquisitive as these artists were with untried media, few were expertly trained in such traditional specialty areas as printmaking or bronze casting. Thus, entrepreneurial individuals stepped in to provide artists with facilities and skilled artisan-technicians to realize their aesthetic goals.

In Los Angeles, June Wayne founded Tamarind Lithography Workshop in 1960 as a means to "rescue" the dying art of fine art lithography. The workshop was fully funded by a Ford Foundation grant until 1970, when it became affiliated with the University of New Mexico, as Tamarind Institute. Its goals were always part educational, part creative, and part commercial, aimed at the education of artisan-printmakers, the production of fine art prints, and the stimulation of new markets for lithography (Tamarind prints in particular).

Gemini G.E.L. (Graphics Editions Limited) began as both a publishing house and a collaborative workshop for artists. Founded in Los Angeles in 1966 by Sidney Felsen, Stanley Grinstein, and former Tamarind printer Kenneth Tyler, its first workshop consisted of a small lithography studio. After an initial mission of creating modest-scale prints for "mature masters" such as Josef Albers, Gemini soon shifted toward working with younger artists who were exploring new horizons of art-making. Rauschenberg was one of the first, followed by other Pop artists, including Jasper Johns, Roy Lichtenstein, and Claes Oldenburg.

In 1969 Gemini responded to the need for more open-ended in-house capabilities by moving to larger quarters, which still function as the heart of the operation to this day. Their groundbreaking efforts over the years include prints in lithography, etching, woodcut, and screenprint, often used in combination, as well as multimedia sculptural projects in multiple editions. Each expansion of the original program required the development of new facilities and materials as well as expanded technical expertise. Gemini became known for its ability to facilitate virtually anything the artist could dream up. As Felsen once noted, "We're a support system, not a co-creator. Each artist is the captain of the ship while he or she is here."[3]

In 1974 Gemini co-founder Kenneth Tyler opened Tyler Graphics in Bedford Village, New York (the facility relocated to Mount Kisco, New York, in 1987). The workshop soon became one of the primary sources of dramatic, oversized fine art prints for ambitious collectors. For established artists such as Frank Stella and James Rosenquist, it was a treasure trove of state-of-the-art equipment, staffed by highly trained technicians who specialized in the printing of mammoth, complicated prints. The works sold for tens of thousands of dollars and came to define the extravagant, bullish art market of the 1980s. As the market declined throughout the 1990s, Tyler found it more difficult to continue his massive operation and decided to close shop in 2001.

Meanwhile, a very different art production facility was getting underway in the upper left-hand corner of the country: Pilchuck Glass School in the Cascade foothills north of Seattle, founded in 1971 by glass artist Dale Chihuly and local art patrons John and Anne Gould Hauberg. The Haubergs owned some former Weyerhaeuser timberland, which they donated to help realize Chihuly's vision of a kind of summer camp and creative laboratory for art glass. The aim was to expand the then-limited notion of glass to a status beyond "craft," and to provide an idyllic setting during the mild Puget Sound summers where students and artists could focus on art and interact with one another away from "the influences of commerce and urban centers."[4] Pilchuck quickly established an ambitious balance between bringing in nationally known (nonglass) artists in residence to work with master craftsmen and women and fostering students interested in learning glass techniques and drawn to the collaborative nature of glass blowing.

The artist-in-residence program is as much a recruitment tool for enticing students as it is an opportunity for the resident artists to create significant works of art in an unfamiliar medium. The list of artists who have accepted residencies is diverse and impressive—Nick Cave, Maya Lin, Tony Oursler, Albert Paley, Judy Pfaff, Lorna Simpson, Kiki Smith, Fred Wilson, Bill Woodrow, and others—and, according to the school's catalogue, they "contribute enormously to the educational atmosphere by orchestrating creative events, initiating critical discussion, and sharing their artistic experience and knowledge."[5] Some of these visiting artists have continued to work in glass; for others it is a one-time summer experiment.

So it is the mature glass artists affiliated with Pilchuck—Chihuly, Bill Morris, Flora Mace and Joey Kirkpatrick, Dante Marioni, and others—who have defined the "art of Pilchuck." Although there is no single aesthetic or style, the school has come to be known and respected for large-scale, highly skilled glass blowing of nonfunctional objects. Pilchuck is a nonprofit entity, funded through the normal nonprofit channels of grants and private donations as well as through a wildly successful annual auction in Seattle that attracts glass collectors from all over the country. Pilchuck has become one of the largest, most comprehensive educational centers in the world for artists and students working in glass.

But bronze is different. Paper burns and is damaged by water; glass shatters. Even older than easel painting, bronze comes with more weight of history than perhaps any other art form. It is, quite simply, one for the ages. Many of the great moments in art history, from ancient to modern times, are marked by bronze sculptures: the life-sized, idealized *Discobolus*, or "Discus Thrower" (450 B.C.) by the Greek sculptor Myron that has become a symbol of the Olympic Games; Ghiberti's magnificent *Gates of Heaven* (1425–52), two 17-foot-tall doors for the Baptistery of the Florence Cathedral with ten panels each, some with as many as one hundred figures set in perfect Renaissance perspective; Verocchio's giant, menacing equestrian statue *Bartolomeo Colleoni* (1483–88); Bernini's 100-foot-high *Baldachino* (1624–33) for St. Peter's in Rome; Auguste Rodin's portrait of *Balzac* (1892–97), considered the first great modern sculpture in its combination of Impressionist surface and internal emotion; Constantin Brancusi's celebration of pure

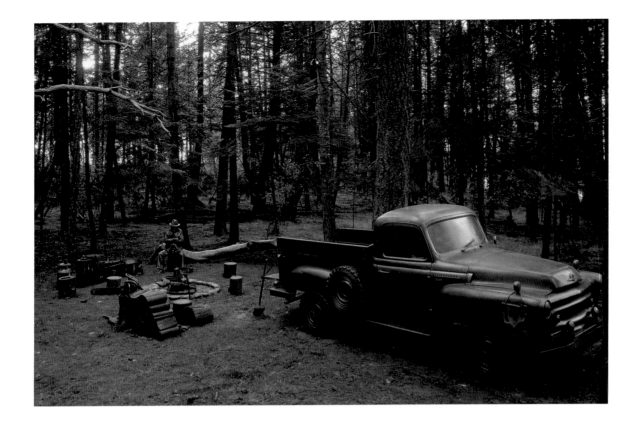

form and movement in *Bird in Space* (1927);
Alberto Giacometti's attenuated figures from
the 1940s evoking isolation and alienation; and
Henry Moore's ebullient, organic abstractions
from the 1950s.

Even in the 1960s, as art was turning its gaze
toward media and subject matter that reflected a
mass-produced, throw-away culture, and artists
began to see the potential in what was being dis-
carded, there was room for bronze. In 1960 Jasper
Johns made a series of bronze castings, including
his *Ballantine Ale Cans*, that combined a "high"
art medium and "low" content to powerful effect.
By the 1970s several bronze foundries were in full
swing, responding to a combination of forces that
included an expanding art market, a new-found
appreciation for Western art sculpture in the
Remington mode, and a renewed interest overall
in contemporary sculptural practice—the decade
being yet another time when the "death of paint-
ing" seemed imminent.

In 1974 sculptor J. Steward Johnson founded
Johnson Atelier in central New Jersey, in part to
rescue a complicated medium from falling into
disuse by a contemporary art scene that largely
eschewed traditional craftsmanship in favor of
new media. Johnson wrote, somewhat arcanely,
"There is no art more dependent on its technical

aspects than sculpture. An ignorance of technique
limits a sculptor's creativity, wastes hours of work
in bringing a cast to a likeness of the original, and
renders the artist captive to the foundry's trade
secrecy and commercialism."[6] Johnson Atelier is
a combination nonprofit educational institution
(offering a comprehensive apprenticeship pro-
gram), full-service production facility for cast-
ing bronze and fabricating metal sculpture, and
indoor and outdoor exhibition venue, all on a
twenty-two-acre site. They do work for hire, in-
cluding a Korean War Memorial in Illinois and
bronze fountain sculptures in Dallas. They also
allow emerging artists the opportunity to work
with experienced art technicians to gain the
knowledge they need to produce their own work,
and provide casting services for artists, including
Kiki Smith and Mel Kendrick.

Another "full service" bronze facility is Tallix
Foundry, which was founded in 1970 in the Hud-
son River Valley town of Beacon, New York. Tallix
provides casting services for architects, design-
ers, and artists such as Nancy Graves and Roy
Lichtenstein, and takes on historical restoration
projects. They worked with architects Tod Wil-
liams and Billie Tsien to create the unique metal
cladding for the new American Folk Art Museum
in New York. Other recent projects include

FIGURE 2 Ed Kienholz and
Nancy Reddin Kienholz,
Mine Camp, 1991

FIGURE 3 Deborah Butter-
field, *Walla Walla*, 1995

FIGURE 4 Jim Dine, *Cleve-
land Venus*, 2003, in situ,
Carl B. Stokes Federal
Courthouse, Cleveland

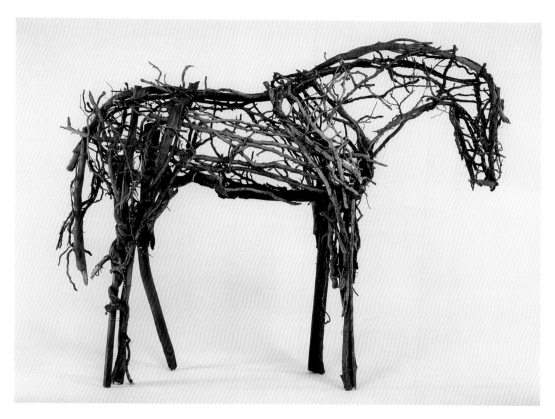

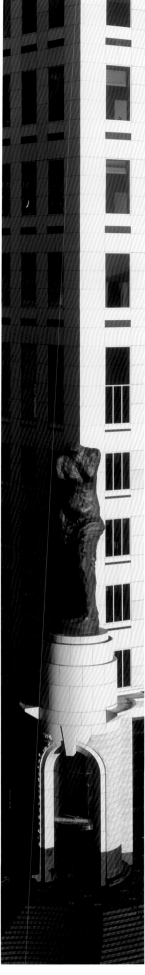

enlarging monuments at Gettysburg, restoring decorative medallions at Radio City Music Hall, and creating a full-scale bronze of Leonardo da Vinci's legendary sculpture of a horse, *Il Cavallo*. Tallix "can cast monumental sculpture and with the same skill and care we can also cast doorknobs, butterflies, or the reins for miniature racehorses."[7] In other words, anything you (or I) might want.

The Walla Walla Foundry is different. The other shops discussed above combine artistic goals with diversified means of funding: production plus sales, art plus "nonart" services, educational missions plus production facilities. Walla Walla Foundry is a private, commercial venue for a regular group of serious artists who produce significant art objects in bronze. The foundry does not sell its own line of work, as do most print workshops. It is not, like Tamarind, Pilchuck, or Johnson Atelier, connected with an educational mission. The artists who use the Walla Walla Foundry use it as a studio away from home, a place, like no other, where they can get things done: a 37-foot-high, 27,000-pound Venus by Jim Dine for the new federal courthouse in Cleveland; the outrageous deer-hunter's camp by Ed and Nancy Kienholz (complete with bronze casts of a 40-foot-tall fir tree and an old pickup truck);

a 24-foot-tall leaf form by Ming Fay for a new building in Seattle, to name just a few.

But you don't simply wake up one day and decide to open a world-class sculpture facility in a small inland Northwest city, miles away from anything resembling an art center. In fact, the evolution of the foundry seemed almost to happen of its own accord. Anderson started out as an assistant to a local sculptor who had opened a foundry. The artists they worked with were all Western/Cowboy artists, and this helped define Anderson's aesthetic direction and goals—away from the superrealism and narrative nostalgia of Western art and toward the personal expression and unpredictable imagery of the most ambitious contemporary art.

When Anderson opened his own foundry, Bronze Aglow (as it was initially called), he envisioned it partly as an extension of his art-making and as a means to subsidize his own sculpture by casting works for others. The eventual focus on working with major contemporary artists came about through a chance encounter with Bay Area sculptor Manuel Neri, who came to Walla Walla in 1980 to speak at Whitman College. Neri mentioned that he was casting bronze in Mexico with mixed results, so Anderson proposed working with him. It proved to be entirely propitious. The

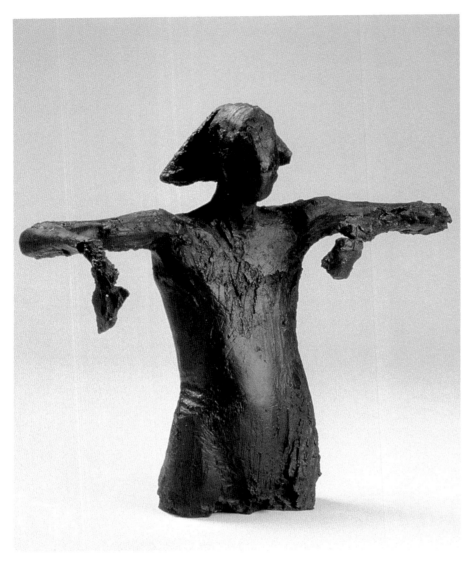

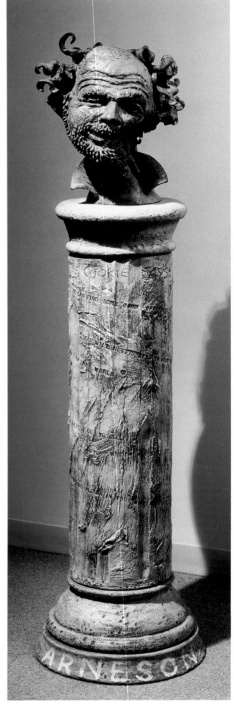

FIGURE 5 Manuel Neri,
Posturing Series No. 3, 1980;
first sculpture cast at
Bronze Aglow (Walla Walla
Foundry)

FIGURE 6 Robert Arneson,
Pour Walla, 1981

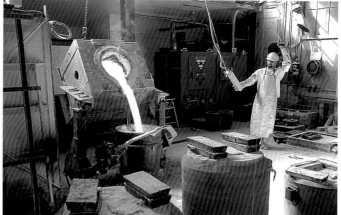

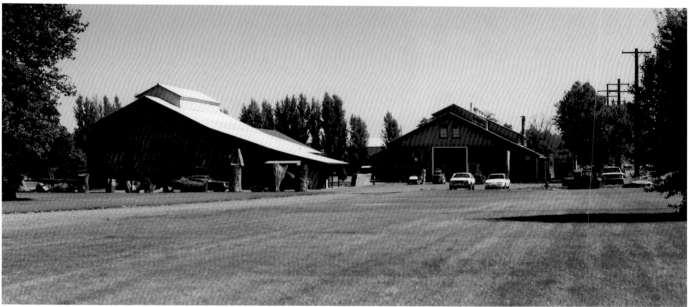

casts were so good that other artists began to take note: first Neri's fellow professor at UC Davis, Robert Arneson; then Dine, who was showing in the same San Francisco gallery as Neri; and Deborah Butterfield, who was a former student of Neri's. David Bates, known primarily as a painter until hooking up with the foundry, heard about it from Dine at an opening in Fort Worth, Texas, and separately from Honolulu-based collector Laila Twigg-Smith. Since those early encounters, Anderson hasn't had time to look back.

From a two-person operation in an auto garage, Walla Walla Foundry has expanded to a thirty-person shop that inhabits four beautifully renovated workshop buildings originally built in 1903 for Walla Walla Ironworks. The four-acre site west of downtown includes an expansive lawn that functions as an outdoor sculpture garden. The atmosphere is casually businesslike. It is staffed by people who know what they are doing

and are attempting to be as efficient as possible within the unpredictable limits of a given artist's creative timetable. The foundry keeps up with the latest advancements in the field, including recent applications of 3-D computer modeling, and is continuously upgrading the tools available to artists at the facility.

Mark and Patty Anderson's spirit of supporting artists pervades the site. Indeed, that openness to the creative process is precisely what the artists who work there find so compelling. The whole place seems to run on the premise of Kirk Varnedoe's description of modern art as the "acceptance of the strange as useful and the reconsideration of the familiar as fraught with possibility."[8] For example, when Tom Otterness heard about the annual hay-bale art contest near his part-time residence in Havre, Montana, he called Anderson to help him create three 15-foot-tall steel stick-and-hay-bale figures,

FIGURE 7 The foundry before restoration, 1985

FIGURE 8 The foundry in action

FIGURE 9 The current facilities of the Walla Walla Foundry

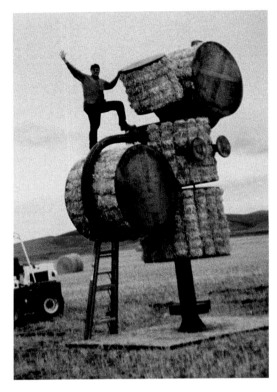

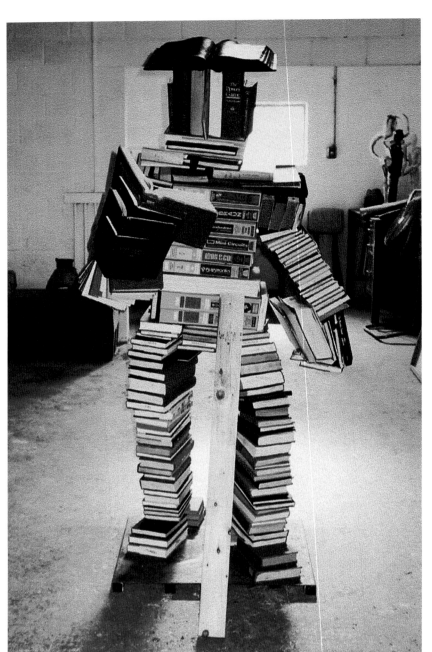

FIGURE 10 Mike Mironov of
the Walla Walla Foundry
at the installation of Tom
Otterness's *Makin' Hay*,
2002

FIGURE 11 Mark and Patty
Anderson in Cleveland

FIGURE 12 Terry Allen's *Read
Reader* in process, 2002

FIGURE 13 Mark Anderson
and Hayes Philo, 1981

which populated an area covering some thirty acres of newly harvested wheat fields, as his entry to the competition. Together they developed a way to keep the hay in the figures, and Otterness ended up winning the modest $100 first prize.

This type of symbiotic relationship between foundry and artist is what sets Walla Walla apart. Relationships have been built over years of working together, so that an artist's development within the medium and his or her ability to push the boundaries of the medium are cumulative. Artists get to know what each part of the team is capable of; the foundry gets to know the specific quirks of each artist. This allows the foundry to function as a source of continuity for the artists, a place where their ongoing explorations can develop as in their own studio environment.

Some artists, such as David Bates, come to Walla Walla for extended stays and literally create from scratch on site. Terry Allen's *Read Reader* (2002) was assembled from books found in Walla Walla shops. Dine has gone so far as to purchase a home outside of town, and uses the foundry as *the* place in the world where he creates sculpture. In another vein, the Kienholzes would drive down from their home in northern Idaho with all the raw materials they needed and an exact vision, and then work with the foundry to make it happen. Deborah Butterfield's process has just recently undergone another significant evolution —from having Anderson cast a crate full of sticks in bronze, which she would then assemble into a sculpture, to creating entire sculptures in wood and then shipping them to the foundry to be cast in bronze.

The fact that Mark Anderson began this journey as an artist himself suggests a special responsiveness to understanding an artist's needs. Walla Walla Foundry is not just a business where they cast, for hire, whatever someone wants; it is an *artists' foundry*, run by an individual with an artistic temperament and the desire to be part of a process of creating great art. Anderson humbly states that he merely helps artists complete their ideas. For Dine, like many of the artists who keep going back to Walla Walla, the relationship goes deeper: he views the foundry as "an extension of the artist's hands."[9]

Notes

1. Walla Walla Foundry press materials, http://www.wallawallafoundry.com.

2. Jim Dine, in "Nurturing Venus," *Walla Walla Union-Bulletin*, March 23, 1989.

3. Sidney Felsen, quoted in Ruth E. Fine and Charles Ritchie, "Art and Technology," *Gemini G.E.L. Online Catalogue Raisonné*, National Gallery of Art, Washington, D.C., http://www.nga.gov/gemini/essay.htm.

4. Pilchuck Glass School home page, http://www.pilchuck.com/about/about_main.html.

5. Pilchuck Glass School residency programs, http://www.pilchuck.com/residency_programs/airs.html.

6. J. Steward Johnson Jr., Founder's Statement, http://www.atelier.org.

7. Tallix Foundry Web site, http://www.tallix.com.

8. Kirk Varnedoe, *A Fine Disregard: What Makes Modern Art Modern* (New York: Harry N. Abrams, 1990), p. 22.

9. Quoted by Mark Anderson, in an interview by Keith Wells; see p. 24 in this book.

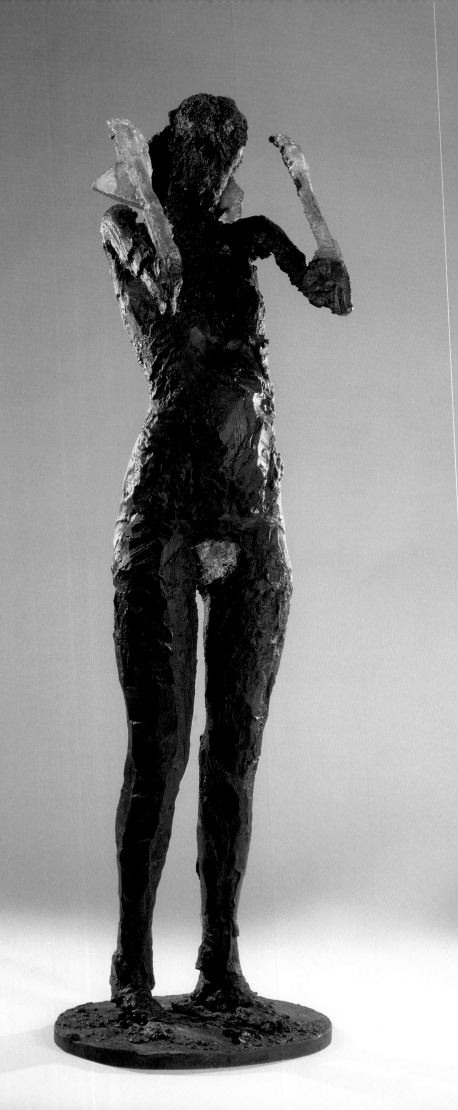

O n November 3, 2oo3, Keith Wells, curator at Washington State University Museum of Art, and Mark Anderson, founder of Walla Walla Foundry, sat down to discuss the evolution and innovation of the foundry as well as some of the memorable moments in its nearly twenty-five-year history.

Keith Wells Where did you learn the process of bronze casting?

Mark Anderson I first learned about bronze casting from Mike Maiden, whom I met in 1973, when I was a freshman at Whitman College.[1] Mike was working nights for the art gallery at the college, and I worked with him part time, arranging artworks and moving exhibition materials. Mike had attended Central Washington State University and graduated with a degree in sculpture. He was interested in leaving his day job as a junior high school art teacher and starting an art foundry. That summer I volunteered to help him build foundry equipment and find artists wanting to do bronze casting. My interest in art and casting grew even more when I saw an exhibition by the new Whitman College professor Ed Humpherys. The show included ceramics and also some castings in aluminum and bronze. That was my first real introduction to sculpture as a college student. It changed the way I thought.

KW What led you to open your own foundry?

MA I worked with Mike through that summer of 1974, and then went to college part time while I continued working for him another full year. I would leave work during the day to go to my classes and then come back and work late into the night. It was a tough road but it gave me an opportunity to learn the nuts and bolts of the lost-wax casting process. After about a year and a half, I left Maiden Bronze to finish my art degree. I was extremely fortunate to land a teaching job in Walla Walla just two weeks after I graduated from Whitman. The local community college was expanding and needed another art instructor. Over the next three years I taught at WWCC as well as one year at Walla Walla College. That was a crazy time, bouncing back and forth between two colleges. Although I really liked teaching, neither college allowed instructors to make art on campus. You could only make art to provide an example of a process for a class demonstration. That was a real drawback. I must say that not being able to make art while I was teaching was the biggest factor in my leaving and starting the foundry. I wanted to be an artist, but didn't think I could make an income right off the bat; so instead of teaching I planned to cast bronze for other artists and still have time to make my own art.

Manuel Neri, *Untitled Standing Figure No. 5,* 1980

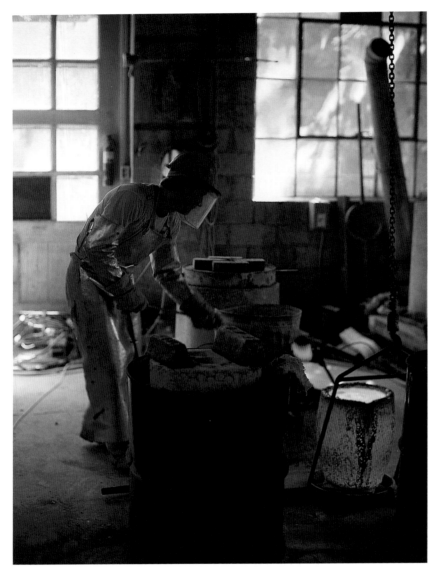

KW You began the foundry as a practicing artist and that sensibility is something all the artists we've talked to have commented on. At what point did you decide to stop making your own art and begin to facilitate other artists' processes?

MA That's an interesting question, and even I'm a little bit puzzled by it. When I started the foundry, I made a decision, from day one, to cast contemporary art. In part, it had to do with not wanting to compete with my friend Mike Maiden. He had taught me, and I didn't think it would be ethical to compete with him. Fortunately, I wasn't really in tune with the Western art market, which was his focus. When I opened the doors it was my intention to be an artist, but something else took over. As I look back on it now, I was fortunate to get in with some great artists right at the beginning—Manuel Neri, Robert Arneson, Stephen De Staebler, Bob Hudson—all these San Francisco Bay Area artists who were making great sculptures. I felt comfortable in that world, working hard to create what they were after. And then, some of it was just the demand—I just happened to be in the right place at the right time; the early 1980s were really good for contemporary artists.

When I went to Whitman College I actually started as an economics major. I think I always wanted to be in business. Looking back, I can see that my creative energy really was directed into sculpting a business. I have always pushed to make the process and our workplace better. We started the foundry in a small studio, and constantly strive to evolve into something better. When we bought our current location, I believe my friends thought I was nuts. It was a couple of hundred-year-old buildings on four acres. They

FIGURE I Mark Anderson at the Bryant Garage, 1984

PROCESS
CASE
STUDY
JIM DINE'S
CLEVELAND
VENUS

were literally falling down. But for me, I could see the potential of what it could become. It's like making sculpture. You start with something raw and you make it what you want.

KW How did Manuel Neri and Bob Arneson find you?

MA Well, I found Manuel, and Bob found me. Manuel had a show at the Olin Gallery at Whitman College in 1980. During a lecture he gave there, he showed slides of his recent bronzes, which had been cast in Mexico City. My first thought was: Why go so far to have your work made? I followed up with a letter asking if I might have the opportunity to cast some sculptures for him. I don't remember if Manuel called me back or if I called him, but he did agree to let me cast two torsos. We planned a time and I drove to Benicia, California, and worked in Manuel's studio making the rubber molds of each torso. Then I took the molds back to Walla Walla, cast the pieces, and drove them back to Manuel's studio. This became the norm from then on: making molds in the artist's studio, taking the molds back to Walla Walla, casting them, and delivering the bronzes back to the studio—repeating the operation every six weeks for the first five years of the foundry.

During one trip to Benicia, I was working at Manuel's and his neighbors walked in, Bob Arneson and Sandra Shannonhouse. Bob asked about molding and casting a self-portrait he had sculpted. It was a little over life size . . . kind of his interpretation of a traditional Roman bust, with the eyes missing. But Bob wore hearing aids, and he sculpted the hearing aids into this Classical-

looking bust. So I made three or four castings for him, and that was the beginning of a long working relationship with both Bob and Sandra, who was also a sculptor.

KW How did the word spread about the foundry after that?

MA Bob, Sandra, and Manuel had a lot of friends. That's how the word got out! Over the next few years, the foundry cast for Stephen De Staebler, Viola Frey, and Robert Hudson. Manuel helped introduce Jim Dine to the foundry too. They were both showing at the John Berggruen Gallery in San Francisco at that time. Dine saw some of Manuel's castings and asked Berggruen where the sculptures had been cast. So Berggruen set up a lunch with Manuel and Jim, and I guess I got a good review. The next thing, Jim was calling the foundry and asking to have his sculpture *Study for Two Venuses* cast. As I've told a lot of people, I'm glad I paid attention in my college contemporary art history class. When Jim called I almost thought it was one of my friends playing a prank on me. But luckily I didn't hang up, and that was the start of Jim coming to Walla Walla.

Another connection that happened was with John Buck and Debby Butterfield. Both of them studied under Arneson and Neri at UC Davis. When they wanted some casting done, they asked the artists they knew where they had their casting done. So, to answer your question, word of the foundry has always been spread by the artists who work here; we have never advertised. From the start my commitment was to working with contemporary artists, and things just grew from there.

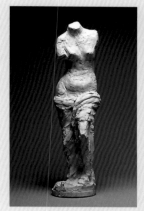

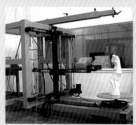

1 *Jim Dine's original 24-inch plaster Venus model.*

2 *Laser scanning of the Venus model.*

3 *A computer-controlled carver starts cutting one of many sections that will be assembled into a full-size EPS foam model.*

4 *Several of the enlarged mid-sections are fitted together.*

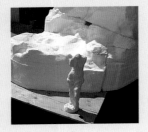

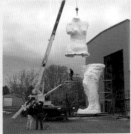

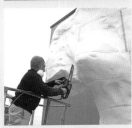

5 *The original Venus model stands alongside the base of the enlarged 37-foot foam sculpture.*

6 *The two multi-sectional foam models are assembled with the use of a boom truck.*

7 *Dine sculpts the foam en-largement with an electric chain saw.*

8 *A plaster mold section of the foam model.*

KW Are there special projects that have been particularly satisfying to work on?

MA I honestly can't say that there's one I like more than another. What is so fulfilling about the kind of casting that I do is that all the artists are so different. That's part of the appeal of contemporary art for me—it's a personal statement.

KW Well, give me some highlights about working with the various artists who have come to the foundry over the years. What was it like to work with Nancy Graves?

MA Nancy Graves was so intense when she made art. To begin the process, she would collect objects of interest to her—a paper doily, a pasta strainer, pasta, ginkgo leaves, whatever—and send them to us to cast in bronze multiple times. Then when she showed up it was time to follow her lead. She would keep every person in the metal shop busy—all at the same time. She would go from one welder to another—placing an object and while it was being welded, going on to the next guy, and so on. Nancy would flow like a river.

KW . . . Deborah Butterfield?

MA Her sensitivity to materials and to the image of the horse . . . it's inspiring to see these forms take shape. She has an intuitive approach to materials that is totally unique. When she first started working with us, she came to Walla Walla with her newborn son, Wilder. To make life easier, Patty and I invited her to stay with us instead of at a motel, and our son, Jay, was about one and a half years old at the time. So our professional relationship grew

in tandem with our personal friendship. Debby's response to materials, to found sticks, is remarkable. I've worked with her for almost twenty years and I am still amazed at how she intuitively knows where to place each piece of wood. She gives each sculpture a personality. We have been able to slowly evolve the casting process so that she has the freedom to choose any piece of wood and we can direct cast it in bronze without taking a rubber impression first. Instead of the lost-wax process, we call it lost-wood casting or direct burn-out.

KW . . . Jim Dine?

MA Jim's approach is totally different. I've seen him create what I consider to be masterpieces in a matter of minutes because of the way he can focus his ideas and concepts. He can take something ordinary and transform it into a different relationship; by juxtaposing the imagery it suddenly takes on a new meaning. His energy level is over the top. When he comes to work he knows what he wants, is very direct, and expects what he asks for to be done and in short order. I like his style. All the people at the foundry like to rise to the occasion and make things happen. Jim is demanding, but always fair. He appreciates what we do for him and we, likewise, know that the work will probably end up being seen by a large audience, in museums or great private collections.

KW . . . Manuel Neri?

MA My first client, Manuel Neri, has only been to the foundry a couple of times in all the years we have worked together. It's a different relationship—he's not about being involved in the

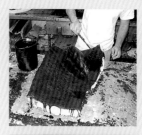

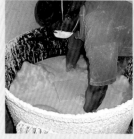

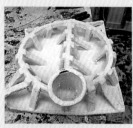

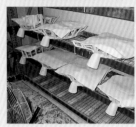

casting process. We reproduce his work in bronze. It's a very traditional approach. But he is one of my favorite artists. From the first time I went to his studio, I felt his passion of sculpting the figure. It's hard to put into words—the awe I felt is still with me. If I could sculpt like Manuel, I'm not sure I'd own a foundry.

KW And Robert Arneson?

MA It was also great being with Bob in the studio and making a rubber mold of one of his ceramic sculptures. While he was sculpting, we spent a lot of time just talking, about art, about life. Bob was always in control. He worked at a speedy pace and was what I would call an "Old Master" type of artist. By that I mean that he would do a drawing, then a small maquette of his idea, and then sculpt the image full size. It was a classical approach to sculpture. I remember watching Bob on his first visit to Walla Walla, breaking his tradition and working directly in wax. This was the first sculpture I cast for him—a life-size self-portrait bust. When he came to the foundry we had about six wax copies ready. It was summer, and Bob took the waxes outside and just waited awhile. The wax softened in the heat, and then Bob stood in front of one of the wax versions and poised himself, arms raised up to his shoulders, and then, bam!, he smashed in the sides of the wax, causing the head to collapse. He did this with each head, and then began to study the new form—cutting, twisting, adding to make new sculptures from these distorted patterns. He never seemed to fret about what he was doing. You could tell he had it under control and it was going to come out exactly the way he wanted.

KW Knowing your appreciation of the artist's studio environment, do you provide a space like that for artists at the foundry?

MA We do have an 800-square-foot studio set aside for artists, but the entire foundry usually becomes one big workspace when an artist visits. I try to schedule one artist at a time—not to say that always happens. But we try to give our full attention to each artist who comes to the foundry. And we do promote the idea that work can be created on the spot, if that's how an artist likes to work.

I love walking into the studio and seeing an artist at work; it adds another dimension to the foundry. To be able to walk into another building and see an artist creating something out of plaster or welded steel, or carving something out of wood . . . it's energizing. And it allows me to see the whole scope of the creation of the work, not just the end of it, which would be the bronze casting. We can see it from start to finish. That's what I like.

KW Tell me about some of the processes and techniques you've pioneered in the field of bronze casting, such as the patinas you use?

MA Well, patinas have been around forever and a day. We have the formulas just like everyone else. But again, working with contemporary artists opens up new possibilities. They have a unique direction, and with that comes unique color. They'll have an idea, and we work toward trying to achieve that concept of color on the bronze. We've worked out a good technique, which allows us to have colorations that aren't too fragile or tentative; they will last a long time. But the inspiration

9 *Wax is brushed onto a plaster mold section.*

10 *Stucco is applied to a wax pattern section during the ceramic-shell casting process.*

11 *A shell-coated wax pattern with wax feeder gates.*

12 *Shell-coated wax patterns, with gating system attached, dry between coatings.*

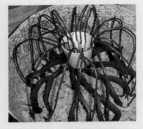

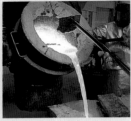

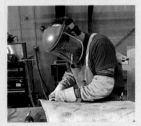

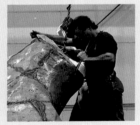

13 *Red wax gates, vents, and cup are attached when making a plaster-based investment mold for some of the wax patterns of the Venus.*

14 *2000° F bronze is poured into a plaster investment mold. After cooling, the bronze panels will be removed from the plaster molds.*

15 *Foam model sections, after plaster molding, and bronze panels are ready for assembly.*

16 *Surface flaws are corrected before the bronze panels are fitted together.*

17 *The upper sections of the bronze panels are fitted and welded.*

comes from the artist; we're just trying to fulfill a need.

KW What about the digital process that you are working on now?

MA Our digital operations are similar to those used by Nike, boat builders, Boeing, General Motors. With rapid prototyping you can make a digital file of the original creation and basically build it by hand in a computer program. We use a laser scanner to scan a model, and then capture the digital imagery. Digital operations allow us to explore a new range of ideas. You can take a two-dimensional object and pull it into three dimensions by converting the pixels, which can be manipulated and distorted and twisted. I consider digital imaging and the ability to "carve" using the computer as an up-front process to bronze casting. Artists have always asked foundries to take a small model and enlarge it. That's very traditional. Using digital technology, we can now show artists other images that can be created, and they can view them on a computer screen and explore all the possibilities without actually physically creating them. They can use the computer like a sketchbook, working from their imagination. Once they arrive at an image they like, they can add and subtract, they can combine different images, or we can carve it at any scale. Once the model is created, the artist can add texture to create even more surface interest. It makes the process even more efficient, and I guess I'm always interested in being efficient and keeping costs in check. There's definitely an investment in equipment and computer programs, but it allows larger-scale work to be created more easily than

before. You can use the application to look *inside* a sculpture and determine, ahead of time, how the internal structure for a large-scale sculpture should be made and whether it will be structurally sound. With that information, we can adjust the model as needed and come up with the best solutions.

KW What level of participation in the creative process are you or have you been willing to share with the artists?

MA I've always said the foundry can't make anything without the artist. Our role is to assist the artist, and to that end we present options; that means doing everything possible to make it just like they want it, but sometimes it means offering them a slight variation that makes the casting easier to do. By easier I mean more structurally sound or more cost effective. It's a give-and-take situation. We are part of the creation process, we want to be part of the creative process. Jim Dine has said that he views the foundry as an extension of the artist's hands. I accept that role.

KW That is a very poetic way to put it. I also see your role as negotiator between artist and artwork. The Kienholzes' *Mine Camp* installation strikes me as a good example of the uncommon level of sensitivity and commitment that goes into your handling of every detail of a project respectfully, of understanding the artist's vision.

MA *Mine Camp* was probably one of the most memorable sculptures I've cast. It reproduces a 1950s hunting scene, for which we cast a full-size International pickup truck, a 40-foot-tall tree, a

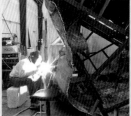

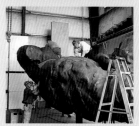

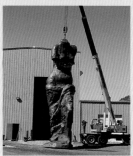

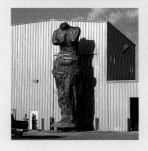

real deer that had been shot, rifles, backpacks, all the food stuffs you'd have along for going up into the woods for two weeks to hunt; we even did a casting of Ed Kienholz, sitting around the camp-fire. It was sort of like documenting a piece of American history. Ed and Nancy were completely attuned to what they wanted, and I appreciate that in an artist. They were able to delineate exactly what they wanted—how many, what style, what texture—and they went and found all these objects. We figured out how to cast a truck and how to give it wonderfully smooth panels. They delivered a deer, which had been shot and gutted, from Idaho. We strung it up according to their specifications, like you would if you were out in the forest. You have to prop open the internal cavity, to circulate air inside and cool it down so it won't rot. We got that all arranged and then put the carcass into a walk-in cooler and froze it rock-hard. We ended up being able to make a beautiful impression of this animal, but we had one stipulation (and they did work with us on this): we found it difficult to have this deer sacrificed for art. So we asked them to come back to the foundry and collect the car-cass, and make sure it was used for something, for dog food or something like that, rather than just being destroyed. It's kind of a gruesome detail, but they understood that this was important to us, and we understood that the deer was a crucial ele-ment of this piece. *Mine Camp* is a reenactment of a hunters' camp, and the deer was the goal of that whole scene. All the details are there. That's what the artists wanted, and we were able to achieve it. I'm pretty happy with that.

Note
1. Mike Maiden now runs the Maiden Foundry in Sandy, Oregon.

18 *The upper bronze section is tested with patina chemicals to select the correct color.*

19 *Sections are welded together and the internal structural support is installed.*

20 *The finished assembly is checked for quality.*

21 *The finished bronze is placed upright before colorization begins.*

22 *The finished sculpture is prepared for shipping to Cleveland.*

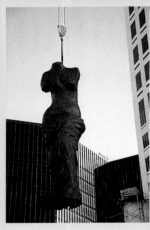

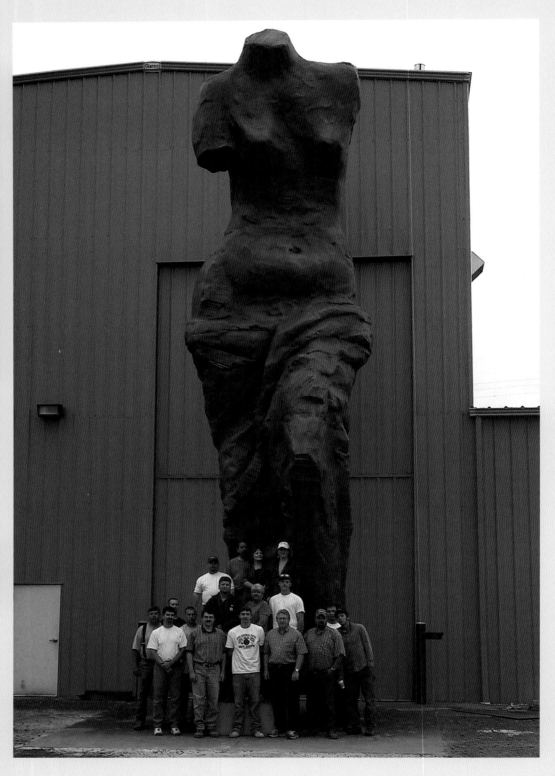

LEFT, TOP TO BOTTOM: Evolution of *Cleveland Venus* from laser scanning of the plaster model to full-size foam model to final cast bronze sculpture

RIGHT: Walla Walla Foundry crew OPPOSITE: Jim Dine, *Cleveland Venus*, 2003

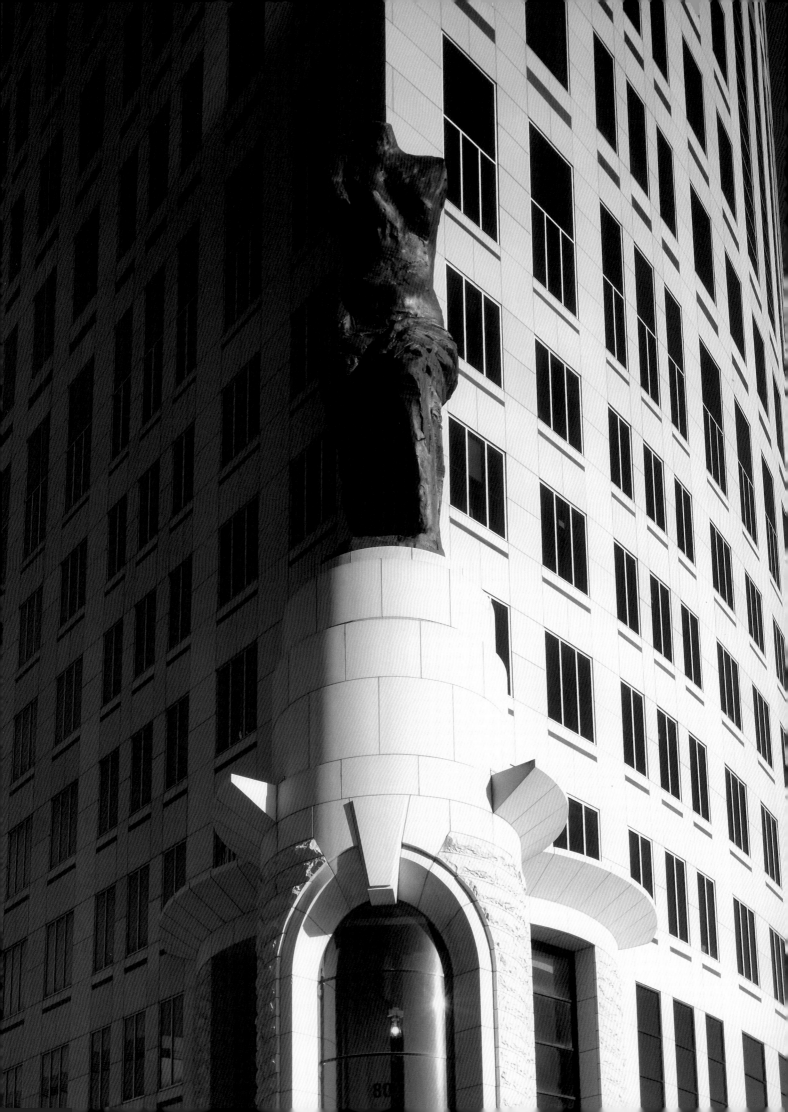

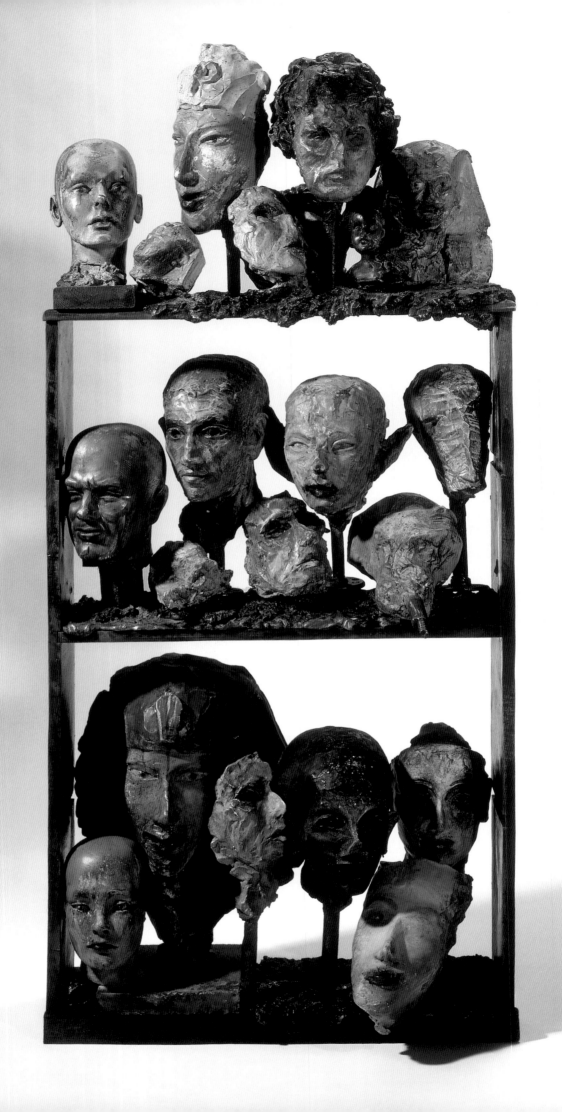

NOTES ABOUT MY SCULPTURE

always made sculpture in one form or another from the late fifties on. Then it was called "assemblage" and a lot of it was putting together things that I found on the street, partly because of financial considerations—I was a very young artist and had no money—but also because I liked the "garbage." I liked the objects that were lying there in the gutter and vacant lots and they resonated for me in the New York City of the late 50's. Even in the 1960's, when I used real tools on the canvas, with paint, I was making bas-relief.

In 1972 at Graphics Studio in Tampa, Florida, I made a progression of objects called *A Plant Becomes a Fan* in cast aluminum, and that was really my first piece of sculpture, using the lost-wax process. It was five pieces that evolved from a plant and metamorphosed into a fan. I also made some reliefs that were "sand cast" incorporating tools, those were cast in aluminum also. I did no more sculpture until the late 70's when I made a few portraits, maybe two or three, in bronze. Then when I was living in London in 1981 or 1982, I had a drink with Barry Flanagan, the sculptor. I asked "Where do you cast your stuff?" I was getting itchy. I had some ideas. He gave me this place in the East End of London called A&A Foundry. I spent a year working with them. I made life-sized *Venus* figures, I made the *5 Big Heads of Nancy*, and a big heart relief there, which the Tate Gallery owns. I didn't like working with these guys. They were "sculpture bullies." Their attitude was the same as people who blow glass in Murano, near Venice, or cast bronze in Pietra Santo, which is a foundry town in Northern Italy where they were trained. If you don't drink with these guys they don't want to see you. I don't mind a drink, you know, but I don't want to be told when to drink, and plus that, they were shitty craftsmen. Sand was always falling out of the sculpture, there were welds that were breaking. At the time Flanagan was with the Pace Gallery so I know this and Pace asked me not to use them anymore because the Flanagans were coming apart. I didn't want to deal with them anymore anyway. I mean, I didn't hate them, it was just a stupid way to work.

In 1983, I went to L.A. for the winter. Gene Summers, my friend the architect and developer, gave me the barber shop in the Biltmore Hotel to use as a studio. He was on the board of the Otis Art School (it was called Otis Parsons then) and he asked, "Would you like to teach?" I said, "I'll do a workshop or something if they'll help me make a bronze sculpture."

So these guys, it was the sculpture department, cast *The Crommelynck Gate* (the one that's owned by the Metropolitan Museum). I mean I built it that winter. We were using wax and steel and they welded the armatures for me and they cast all the tools. I knew I wasn't going to be able to edition it there, I was lucky to get one work out of the experience.

So, I went to San Francisco to see my dealer on the West Coast, John Berggruen, and said, "You know Manuel Neri, and I know he casts *somewhere*, and I'd like to cast some things." Manuel is a very painterly sculptor with a beautiful touch, and I wanted to meet the "foundry guy" behind his bronze sculpture. John arranged a lunch and

For someone who has called such places as New York, London, Venice, Berlin, and Paris home, Walla Walla might seem an odd addition to the list. In fact, it has been a foothold in Jim Dine's life since 1983, when he first began his collaboration with Mark Anderson's foundry. To see Dine in his work clothes at the foundry is to understand the affinity between the artist and the foundry staff. He is a self-described "blue collar guy," a "worker," whose entire career has been hands-on. His sculpture is as much about the artist's touch and individual sense of surface as any painting or drawing—and thus, the importance of a foundry that can translate this vision from artist's hand to finished product.

When I told Dine we wanted to "use" him in the book as a kind of case study for the relationship between artist and facility, he replied, "I am the case study." Indeed, it is hard to separate Dine's development as a sculptor from the foundry's evolution into a world-class facility. His involvement with the foundry for more than two decades continues to be seen as a watershed that has pushed the ambitions of the foundry in terms of scale and technical accomplishment, including recent explorations into 3-D rapid prototype computer imaging. Walla Walla Foundry is one of Dine's many studios, but the only place where he makes sculpture.

—Chris Bruce

Jim Dine, *Books on the Priest's Shelf*, 1990

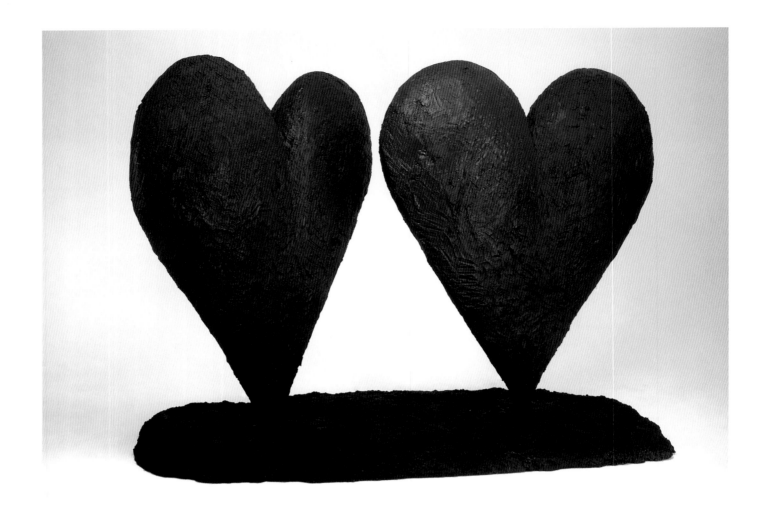

Manuel very charmingly offered up Mark Anderson. Manuel said, "Well, I cast in Walla Walla . . . " and I asked, "What's that like?" "I've never been," he said, "I make the work in plaster and Mark comes down with his truck and gets it." I liked this idea (when I was a kid I had a game called "Geography" and Walla Walla was on there, on the board, the name always caught my eye).

I called Mark, he had a nice voice on the telephone, and he said "I don't know if I can come down right now, my wife is about to have a baby." This was twenty-one years ago, because that's how old Jay is now. He said, "I'll try." And he did come to L.A. to Otis, to the casting yard there. The guys who were working for me really worked him over. They were so jealous because they knew I was taking the project from them. They thought he was kind of a "yokel" *which he was not.* You could say, at that time, he was a young craftsman. He told them that they were wasting a lot of things. He said, "We even bend out used nails." I mean, he was working on a shoestring, and he had two other people working with him. So I said, "Mark, look, can you cast this thing? Can you give me an edition?" He said, "Yes, these castings look pretty good." They were castings for wax, which eventually would be burned out to be replaced with bronze. He said, "I think we

can use them." So, later, he came down with his truck and got everything, and made an edition of six *Crommelynck Gates.* Each one is different, but that's because I put tools on them differently and there are two that are colored, that are painted. That was the first thing I did with Mark, but I also had the molds of those *5 Big Heads of Nancy* from the foundry in London sent to Mark, and he took molds of them, and also he repaired them, welding them, making them stable.

After I found Mark Anderson, I knew he was for me, "a good fit." Now, saying that, it was a pain in the ass to get out there all the time. So, the next year I tried Tallix Foundry. It is up the Hudson from New York City, about an hour away. It was a very bad experience. Big Know-It-Alls. The final blow was when I got back my casting, it was a head, and the nose was pushed in. And you know what happened? The wax had fallen over, smashed the nose, and they cast it anyway. It was very careless of them and I never went back. So my whole deal with sculpture has been with Mark, absolutely been with Mark. I didn't care if it took me longer to get to Walla Walla than to get to Paris. Mark and Patty Anderson and the Foundry suited me fine!

Any problem I have—with sculpture—Mark is able to solve. When I started with him, the Foundry was on Bryant Street. The front part was

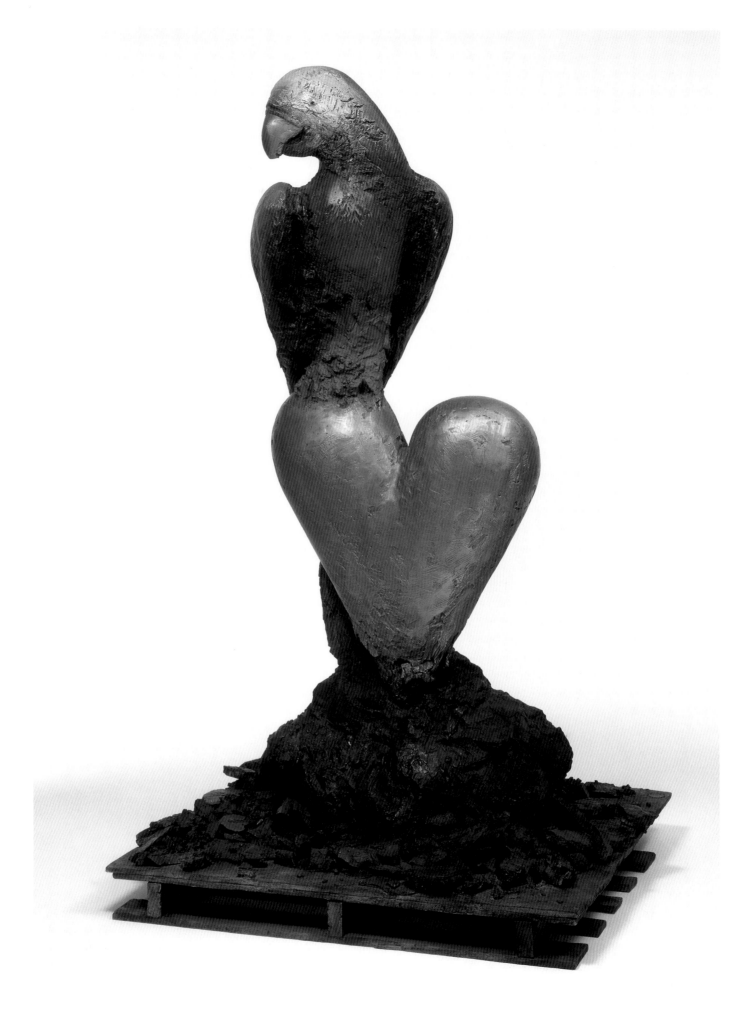

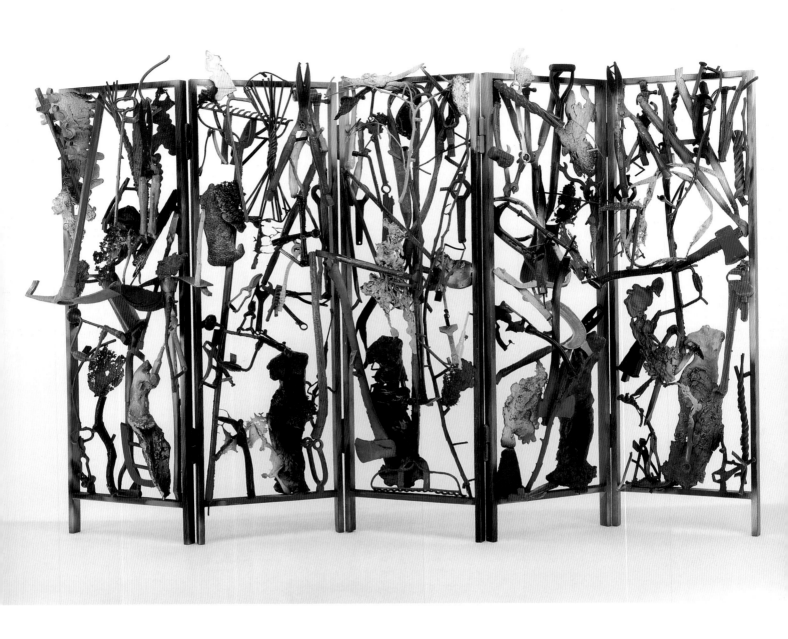

FIGURE 3 Jim Dine, *Garden of Eden*, 2003

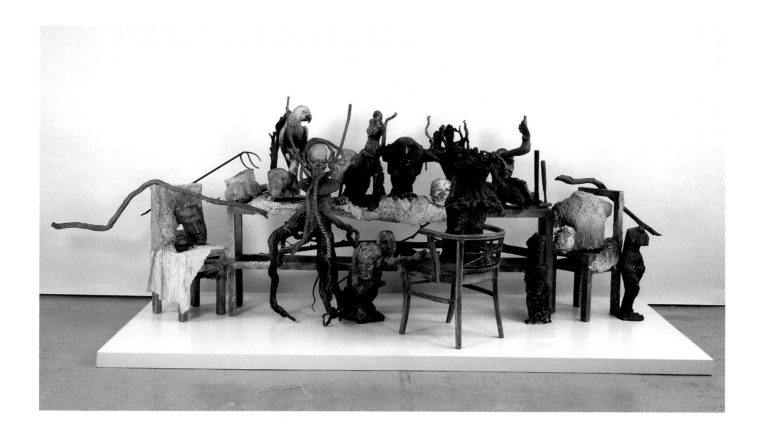

an auto garage and the back was the foundry. It was a very primitive foundry situation. Mark had an oven and he burned out the wax. He was also a welder and there was a guy he went to Whitman College with named Hayes Philo who worked with him. Brad Rude was also there. He was sixteen years old and not doing well in school I remember. He had some learning disabilities like I do, I mean, dyslexia or whatever, but he was into pottery and art. He took ceramics at Walla Walla High School. Anyway, he was an *artist*, plus he was strong and they needed that. He worked after school and all summer and there were three of them learning as they went. I just went there and built things and they cast them for me. I would come back maybe every six months, each time I came back there would be another person working there. Mark was expanding.

In the summer of '84 I was in Aspen seeing one of my sons perform at the music festival. I drove to Yellowstone on my way to Walla Walla to see a friend who had a house there. She had a dinner party, and my dinner partner was Debby Butterfield. The first things I ever saw of hers were these wonderful mud lying-down horses in the Whitney Biennial a long time ago. So, we got to talking, we'd never met before. She was pregnant with her first child, I remember this very clearly,

I said to her "What are you making these days?" She said, "About thirty thousand dollars a piece." I said, "Wait a minute, that's not what I'm talking about. What's the work? What are you doing?" She said, "I'm looking for a foundry." I said, "You gotta come to Walla Walla and meet Mark Anderson." So she came over to Mark's and that relationship has not stopped. I got Gene Summers to come up, who wanted to make furniture. And Gene came up once or twice, he bought some of my work, but he also got excited about the Foundry.

I felt at home there and Mark said I "could do anything" and I could fail. It's tough to make mistakes in casting bronze sculpture. Usually there's no going back, so a mistake can be very expensive. You have to learn to hold back a bit, and hopefully plan carefully. And I made some big mistakes there, things that we never even cast. I hope I've learned a little.

When I first came up north and west to Walla Walla to work, Mark put me up in the Pony Soldier Inn. I immediately went out and bought my electric frying pan, my electric wok, my toaster, and I set up housekeeping there so that every year I put it in a trunk, gave it to Mark and he'd store it somewhere. Each year I'd bring it out, and my old rags that I was wearing. And you know, I bought a bicycle immediately . . . first time I was there I

FIGURE 4 Jim Dine, *Feral Air*, 1992

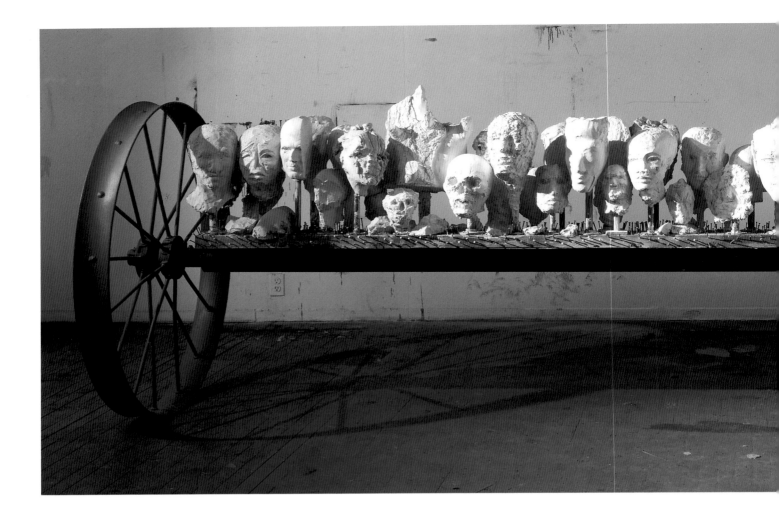

FIGURE 5 Jim Dine, *Big
Rolling Noise*, 1997

bought a bicycle. They all looked at me like I was
nuts, they'd never seen this, a man using a bike as
his preferred form of transportation.

After a while, I remember 1988–89, I thought
I should have a place there. Mark found a church
for me to buy and I bought a little Seventh Day
Adventist church and he supervised while I was
away—the remodeling of the basement so I could
live there. I painted upstairs in the sanctuary and
I bought a pickup truck, which I still have, that has
seven thousand miles on it. That shows you how
much I use it. I sold the church about four or five
years ago, it was falling apart and I wanted to live
in a more light-filled place. I went back to living
in motels, which was great. Now, Diana Michener
and I have just bought a place. We bought the place
because we felt like we were getting older, and
Walla Walla would be a nice place to go to *work*
when city life wears you down. That's the whole
point about the town and about Mark—it's about
work. It's like a vast art store there except it's filled
with supplies, like ranch supplies, that sort of
thing. It's a town of welders. People always make
their own tools on the ranch as it were. It's car
mechanics, there's junkyards all over the place,
there's stuff you can find.

And there are craftsmen. He attracts crafts-
men who can do certain things. And it's been a
constant source of inspiration. It's a practical
muse—the technicians at the Foundry and the
big open sky. The piece called *Wheatfields* is made
because of the *"wheat fields"* and because of the
subliminal observing of the farm machinery
either left to die in the fields or churning through
the earth and making dust on the horizon. I'm into
farm machinery. I was looking at things for years
I thought were more inspirational for instance
than a [Anthony] Caro, and they were made by
International Harvester or John Deere. There
is a piece called *The Mountains that Surround Us*,
which is of a Venus lying down that I painted like
a snowy landscape; a mountainous landscape.
There is very much a sense of my driving around
the countryside on my bike . . . and a big sky, I'm
very influenced by it. I love the sunset. I love the
wheat in the summer time. I love the way it's so
dry here. The town has huge specimen trees, after
all we have an Olmstead park, you know, Pioneer
Park. Olmstead came through and planted it, so
there's an enormous variety of old trees. And I
like also the anonymity of the town. Everyone
leaves me alone to work. That is what the whole
place is about.

Mark and I work together very closely and
very well. He's so efficient that if he doesn't
know something he'll call someone in, one of the

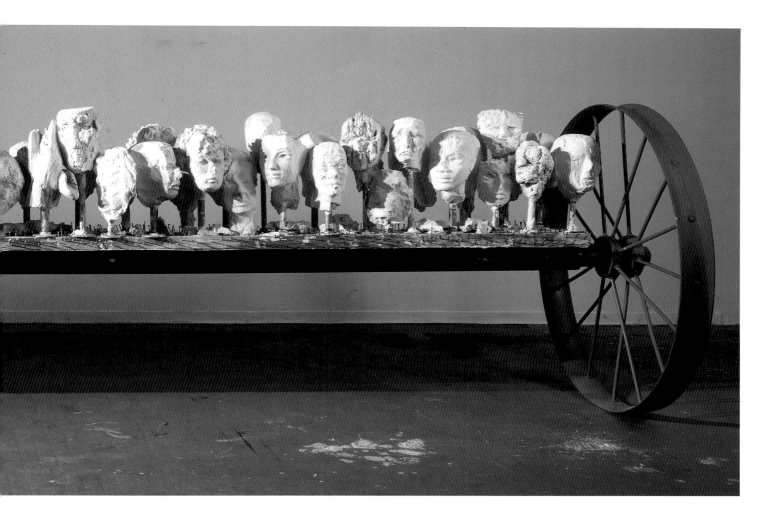

guys . . . to do this, to do that, to give an opinion, to solve a problem, and everyone who works at the Foundry is talented. Byron Peterson is a great technician. He went to high school with Mark. He's a very intelligent welder and engineer of problems—real hands-on. As are all the other guys there.

The guy who started the whole thing in terms of patinas was Brad Rude. We all worked on patinas. We didn't know anything. We had other people's formulas. Mark and I would make it black or we'd make it green or brown, but Brad would experiment with patinas and he developed them because Brad's a painter, he's extremely painterly, he's got it in his hands. Then he quit to do his own work and Squire Broel came in and is also extremely painterly, and he's excellent. So between those people, I don't know how he finds them, but he does, and he's done well that way. Now we have Dylan Farnum. He's an important guy. He came out with Judy Pfaff as her assistant on a project and he stayed. He's a sensitive, excellent man to work with. He has developed computer programs for cutting sculpture and designed a new machine which runs according to his programs. He has found a way to flip my images so we can carve them in a distorted way. The *Venus* can be bent backward, forward, twisted. I make

sketches and say, "Hey, I'd like them to look like this or like this," and then Dylan will program the computer so the machine will carve the foam in that shape, and then they can point up from there. Because I don't like the mechanicalness of it, but I like the gesture, I add clay to the foam, use my chain saw on them, rough up the surface to make them *mine*. I have been working on these Venuses for the last couple of years, but I haven't cast one. I'm still working on them, still playing with them. This summer I will finish them. It's a challenge to get the gesture right.

I can draw, paint, photograph anywhere. I don't do sculpture *anywhere*. The freedom to work in Walla Walla at the Foundry and in the town is exceptional. The closeness to nature is very palpable and a silence is there, too.

Jim Dine, *born 1935, Cincinnati, Ohio; attended University of Cincinnati and Ohio University; lives in Paris, New York, and Walla Walla, Washington*

Dine is regarded as one of the leading figures in contemporary American art. From the beginning of his career in the early 1960s, he has been at the forefront of innovation, working in a variety of media, including sculpture, painting, drawing, photography, and printmaking. Expressionistic and poetic, many of his works incorporate everyday objects and imagery, with strong personal and art historical overtones.

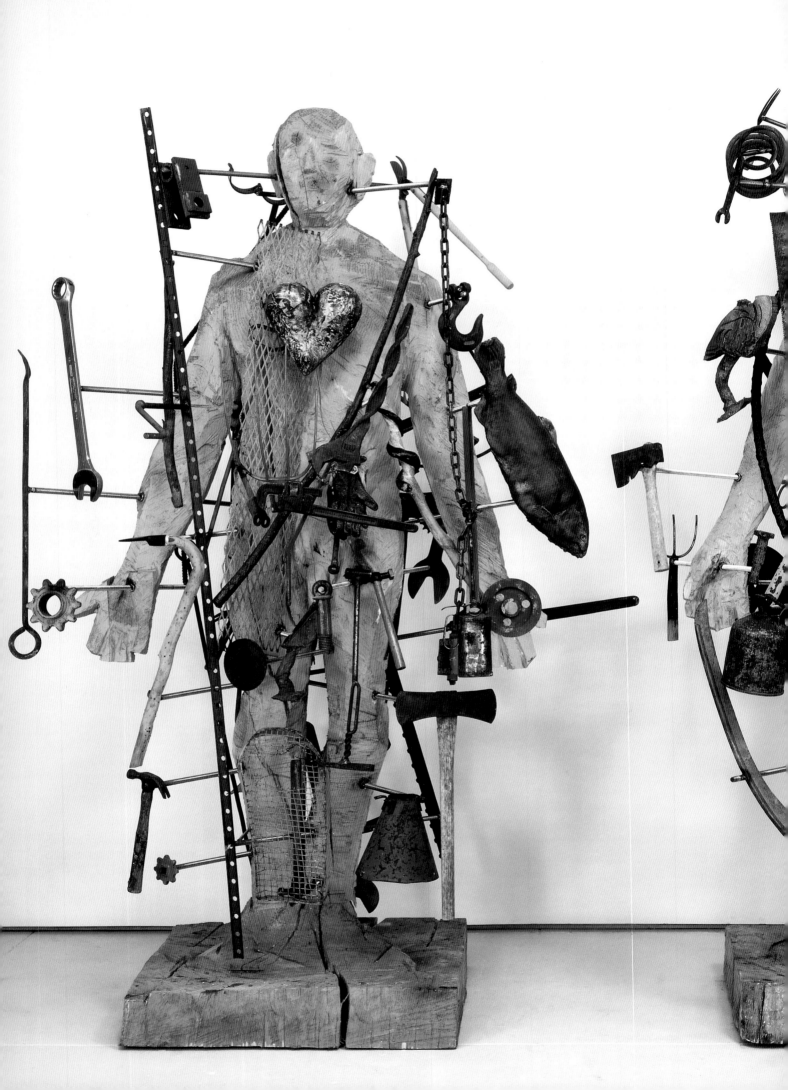

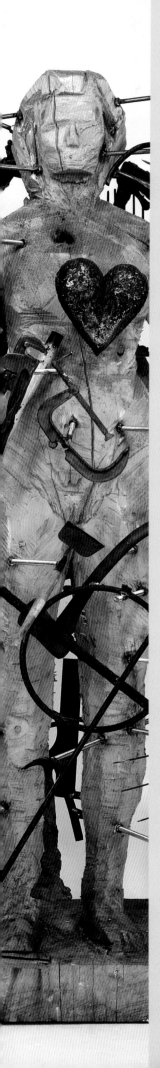

"ANYTHING CAN HAPPEN THERE"
ARTISTS' RECOLLECTIONS OF WORKING AT
WALLA WALLA FOUNDRY

Jim Dine, *Twins in the Forest*, 1989

started working at the foundry right out of high school; I wasn't even an artist at that point. My early decision to work in bronze had a lot to do with the fact that it was so available to me. I was in the midst of it and I saw what it was capable of doing. Its durability, its ability to take an object and reproduce it . . . those things attracted me from the start.

I suppose the most significant attribute of bronze is its ability to connect strong points, strong joints. You can make something that looks like it has a delicate connection, but it's actually very strong because it's welded. With plastic or wood you have to use a pin or tie it somehow or glue it, and none of those are as quick and as strong as welded joints. With bronze you can make something that appears to be very precarious and delicate but in fact is very durable and quite nonbreakable. I think that's why bronze has been such a traditional, tried-and-true material for artists.

Because I worked at the foundry, I knew how to do the entire process myself. My early creative decisions were based on the technical knowledge I learned from working on other people's sculptures, doing the welding, doing the patinas, doing wax work, doing mold work. You gain an understanding of the process to the point that it greatly affects how you would sculpt it yourself. I was able to anticipate things in my own work—how texture and surface would reproduce, how to make a complicated mold in such a way that it can easily be taken apart for rubber molding, etc.

One time, while I was still an employee at the foundry, I had sculpted a life-size cow with a coyote on its back in plaster. I was due for a raise, and so I approached Mark with a wage proposal. He countered by saying that he'd give me a raise, but as part of the deal he'd cast the cow and coyote sculpture for me. So here I was in my early twenties, and I already had a life-size bronze sculpture, which was rare for an artist that young. Bronze is usually reserved for older, more established artists who can afford something that large. It was very exciting, and it was a successful piece. It ended up going to Seattle and became kind of a visual landmark (it eventually sold and is now in Kirkland, Washington). That, in many ways, was the start of my professional career; it all started for me with the big cow and coyote.

Brad Rude, *born 1964, Lewis-town, Montana; attended Central Washington State College and Maryland Institute, College of Art; lives in Walla Walla, Washington*

Rude explores relationships between animals and objects, which he portrays as a kind of spiritual and physical interaction. Working primarily in sculpture and painting, his artworks are imaginative comminglings of the mysterious and the mundane, most often with a humorous touch, sharing a certain sensibility with Surrealism.

1) Into the Calm, c. 1996; 2) A World Beyond, c. 2000; 3) Unpredictable, c. 2003; 4) The Occurrence, c. 1996; 5) Widespread Inquiry, c. 2000; 6) Into the Calm, too, c. 1999

1 >

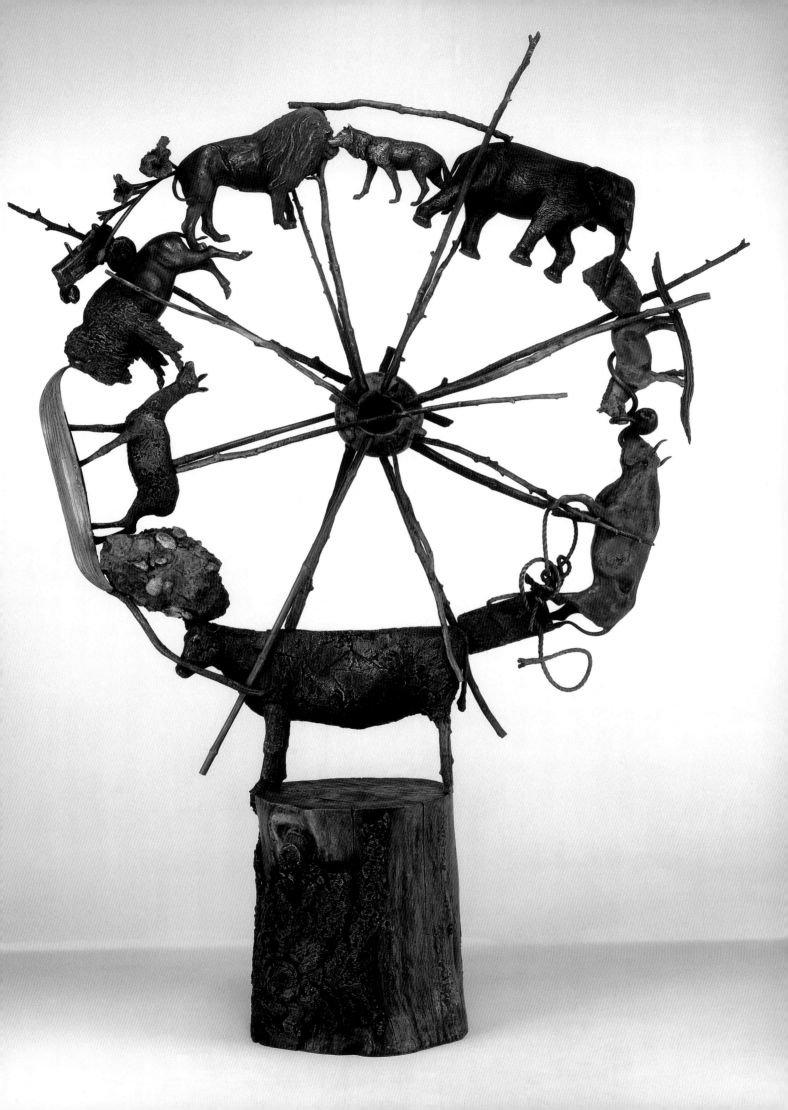

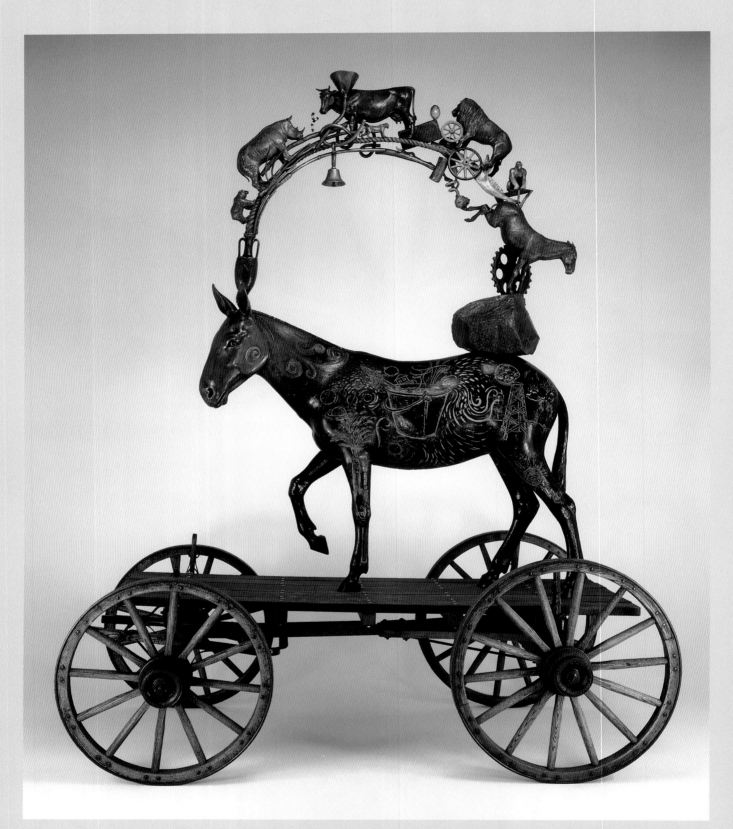

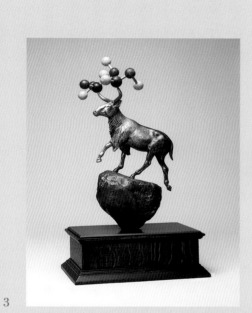

3

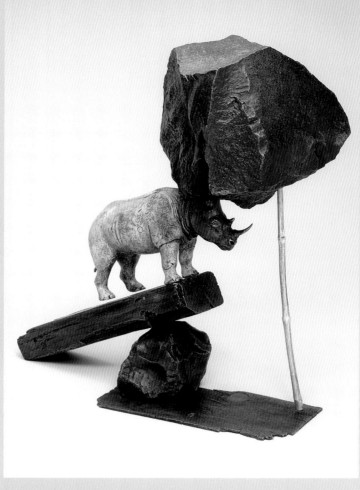

4

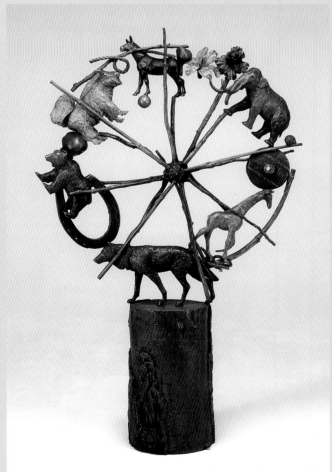

6

5

DEBORAH BUTTERFIELD

Two things prompted me to start working in bronze. First, when I was making stick pieces, I had to tie them together with wire and invariably the wood shrank or the wire stretched and the pieces became deformed. I wanted my work to look the same ten years after I made it. I wanted something that would last and ideally could go outside. And then, around 1984, I was invited to a dinner in Wyoming, and Jim Dine and Martin Friedman from the Walker Art Center were there. And they were telling me about this wonderful foundry in Walla Walla, Washington, and I had been hearing the same thing from Manuel Neri and Robert Arneson. I was very pregnant with my first boy at the time, and I also had my first commission for a multiple. So I knew it was time to get ahold of Mark Anderson.

When I make even a small horse out of just real sticks, I need to use wood that doesn't have any bugs in it or any dry rot and that is structurally sound. But the wood that's most beautiful and interesting to me is wood that's one step away from being dirt again. The more rotten, usually the more interesting. With bronze casting, I can use extremely delicate wood and they burn it out directly. And once it's cast in bronze, it's just as strong as any other piece of wood. It has really enhanced the range of expression in my work. Also, once the work is in bronze, I can still change it. Sometimes I weld the armatures directly out of bronze sticks, and I used to make the whole piece out of sticks that had already been cast in bronze that I would then just weld together. But that was very heavy, and I never seemed to have the right sticks precast. But, even in my working process now, once the sticks are in bronze I can still bend them. We can shorten them, because the welding capacities at the foundry are so amazing, and with their tooling we can add other ends to it; it's just amazing. I can have a full-size bronze sculpture completely done and then say, "What was I thinking?" And we can actually take it apart and rebuild it right on the spot. It has added incredible range and flexibility to my work. You can also roll the work down a mountain and it will hurt only the mountain. Not the horse.

I work hands-on at the foundry, and they also come out and work with me in Hawaii and in Montana. Their role is huge, and all the people there really know how to work and enjoy working. It's almost like dancing, because we work in a whirlwind. I enjoy being with people who also love to work and are good at it. I find it inspiring and fun and energizing. And Mark and Patty's support on a general level makes me feel that whatever I come up with, they'll try to make it happen. Mark sometimes comes and helps us get the wood. Once, when we were in Hawaii, he and John [Buck] climbed down this cliff on the north shore of that big island where Kamehameha was born, and they got all this driftwood up for me, to make a piece; they both risked their lives doing this. That was very memorable.

Deborah Butterfield, *born 1949, San Diego, California; BA and MFA, University of California, Davis; lives in Bozeman, Montana, and Kona, Hawaii*

Butterfield is known widely for her lyrical sculptures of horses, which are constructed of various materials, including wood, metal, and plant fibers. They are characterized by a quiet and contemplative tone, which reflects, in part, the mythic and revered position the horse occupies in Western culture. Butterfield has lived in Montana since 1979, where she has taught at Montana State University, Bozeman.

1) *Untitled*, 2003; 2) *Untitled*, 2003; 3) *Hawaii (Big Island)*, 2001

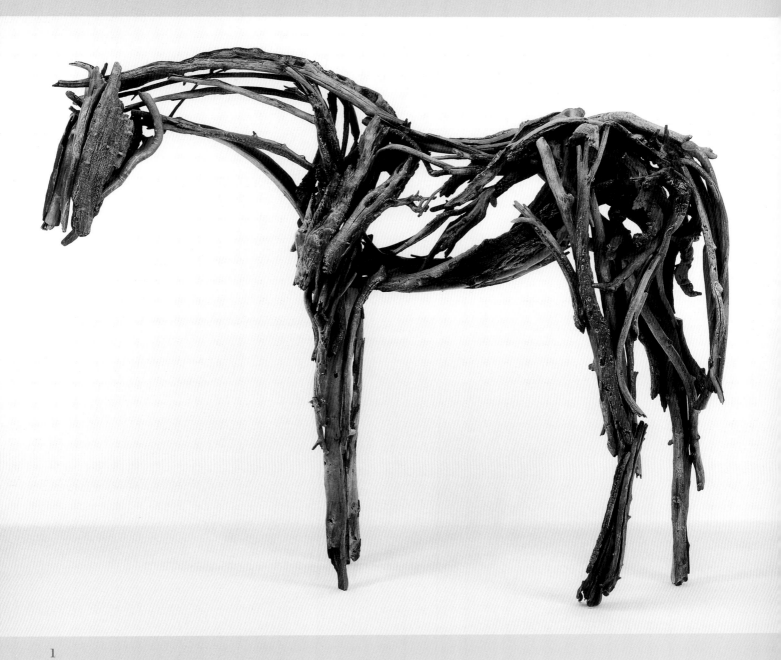

1

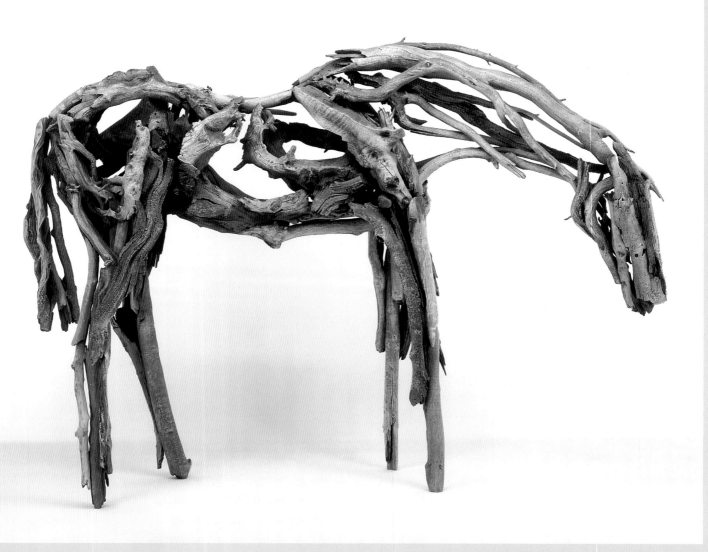

3

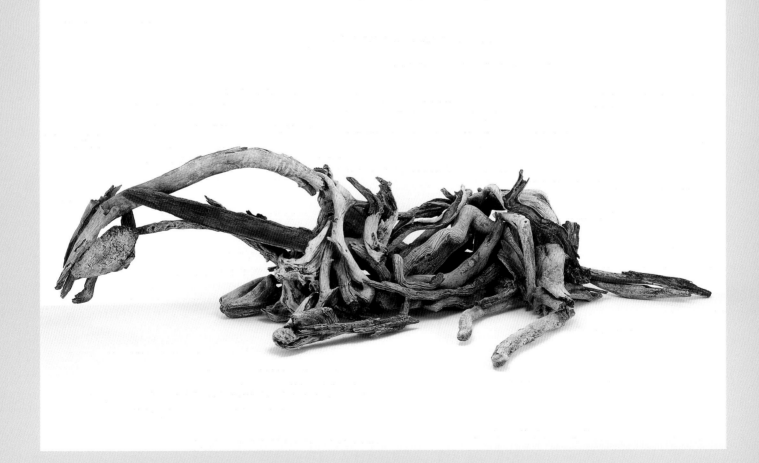

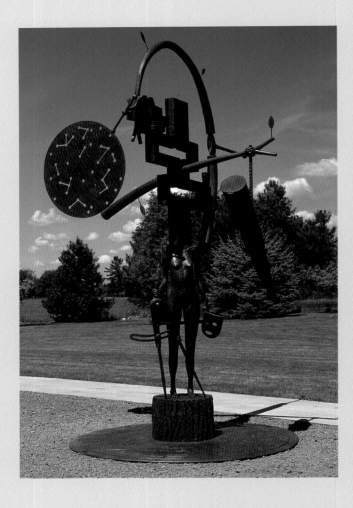

1

JOHN BUCK

'm primarily a wood worker and I've been working with wood for some thirty-five years. It's a wonderful, spontaneous material, but it has limitations. You simply can't put it outside because it will eventually fall apart. Bronze was the logical extension of my work since the wood pieces can be molded or cast directly.

The strength of bronze gives you options to do things that you wouldn't attempt to do with wood. Bronze is a medium that allows me to create things much larger than I might otherwise make them. There is a lot of balancing of structural elements in my sculptures; casting has enabled me to expand on my work that way.

The community at the foundry is remarkable—an incredible number of artistically minded people; they aren't necessarily artists, but they certainly have the same kinds of talents as artists.

John Buck, *born 1946, Ames, Iowa; BFA, Kansas City Art Institute; MFA, University of California, Davis; lives in Bozeman, Montana, and Kona, Hawaii*

Buck's sculptural and graphic works combine a rich amalgam of personal imagery with symbols that reach beyond into social, political, and religious realms as well as folk and popular culture. Based in a formal approach to the human figure, his work integrates elements of painting, printmaking, and sculpture to express imaginative recognitions of the relationships between humanity, nature, and culture.

1) Observatory 2, 1999; 2) Composition with the Head of Mercury, 2002; 3) Music in the Sky and The Hawk and the Dove, 1999

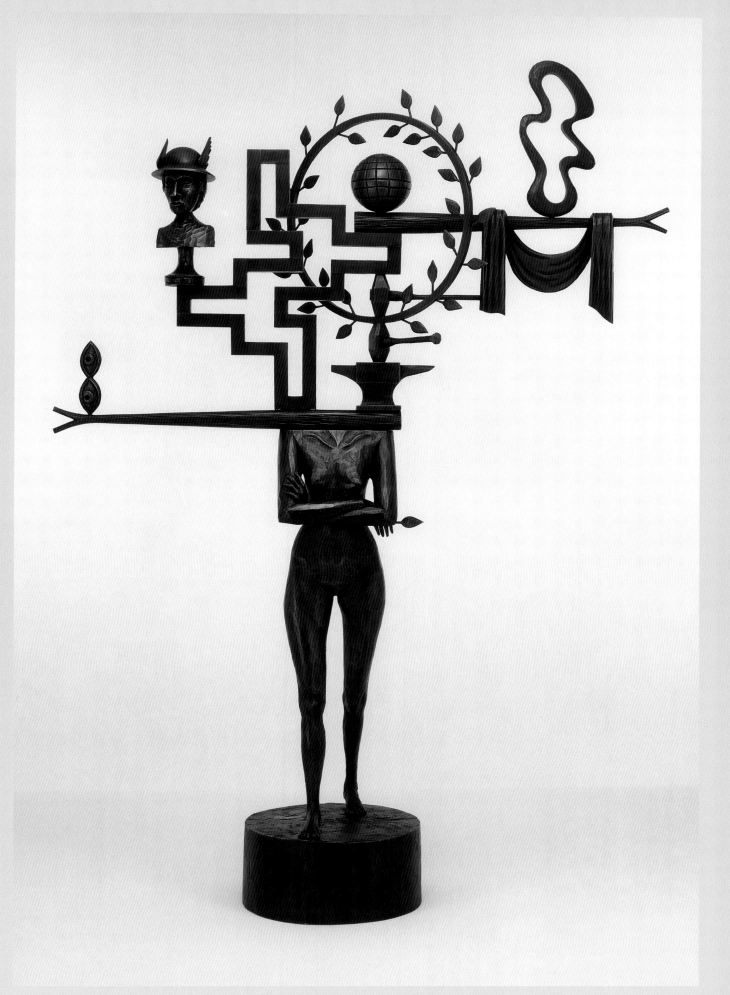

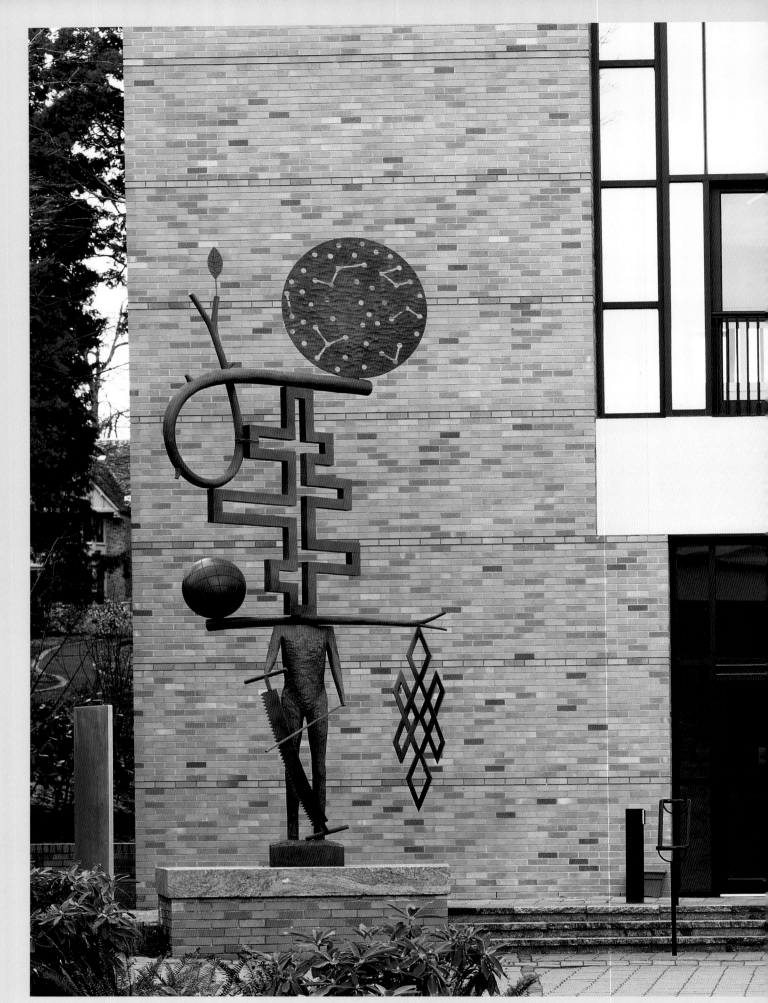

liked the whole process of bronze casting because it was so Martian to me.

I have certain ideas that lend themselves to bronze, but other ideas really have nothing to do with that kind of sculpture. I've often incorporated bronze with other mediums, but it comes down to a question of whether bronze makes sense within a particular idea.

I was knocked out when I went to the foundry because they have a building for each part of the process. And the people had worked with each other for a really long time. One of the things about bronze is that you have to build up a language with the person you're working with, and if that's consistent over a period of time, then you get a real feeling for how each of you works. So, whether it's patina, or chasing, or whatever, every time I go up to Walla Walla, it's the same people that I'm working with and I have great confidence in and am very comfortable with them.

They set everything up in an ideal way for me to work. In the last few pieces I've done there, I've been creating the work at Walla Walla. *Read Reader* is a figure that's made entirely out of real books that were cast. I went all around Walla Walla with one of the people at the foundry, gathering books, and then I built this figure, which they then cast. So with that one, the entire process took place at Walla Walla. I've done more and more that way, using the foundry as a studio. Prior to that, I would work on the clay in my studio, and then make a mold and send them the mold to cast. But over time I've become so comfortable working there; I like working there from start to finish, and it seems to open up all the pieces that I'm working on.

Terry Allen, *born 1943, Wichita, Kansas; BFA, Chouinard Art Institute, Los Angeles; lives in Santa Fe, New Mexico*

Allen works in a conceptual mode to cross a wide range of media, including large-scale tableau-like installations, painting, sculpture, and public art. He is also well known as a songwriter and musician. His art is often politically motivated, addressing such themes as the Vietnam War or the destruction of the natural environment, but he is equally at home with humorous and commonplace themes.

1) *Shaking Man*, 1993; 2) *Read Reader*, 2002;
3) *Countree Music*, 1999; 4) *Belief*, 1999

1

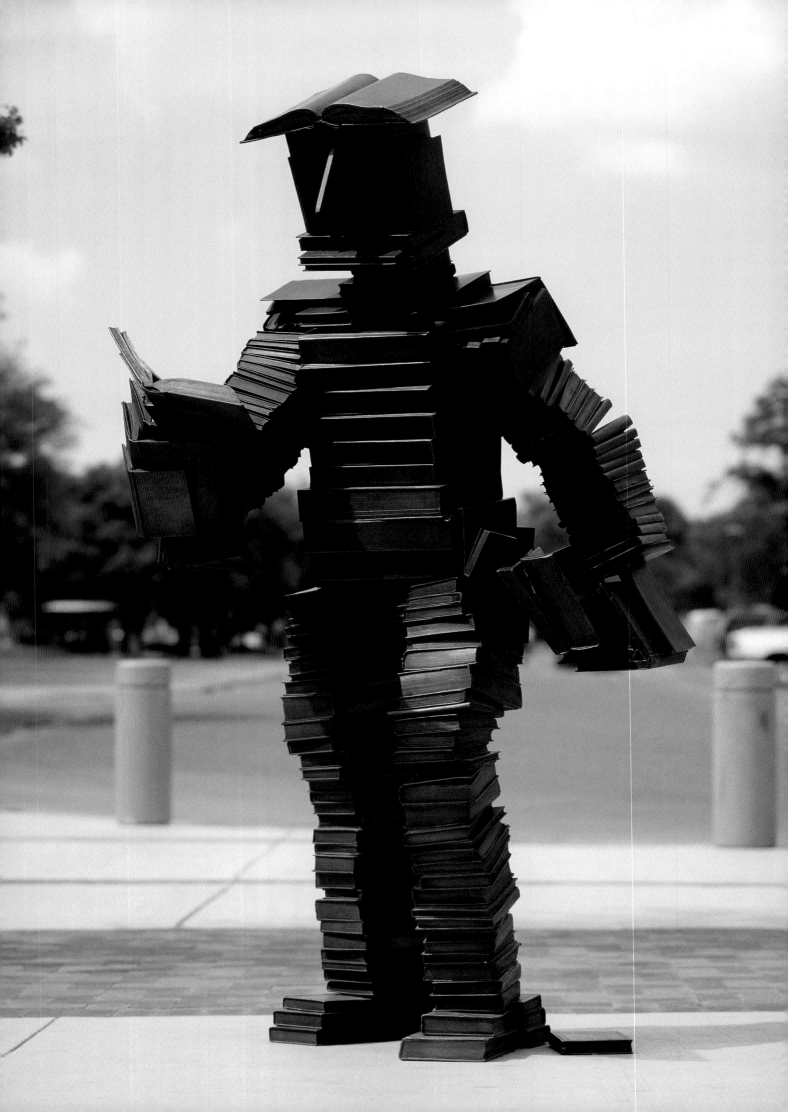

3

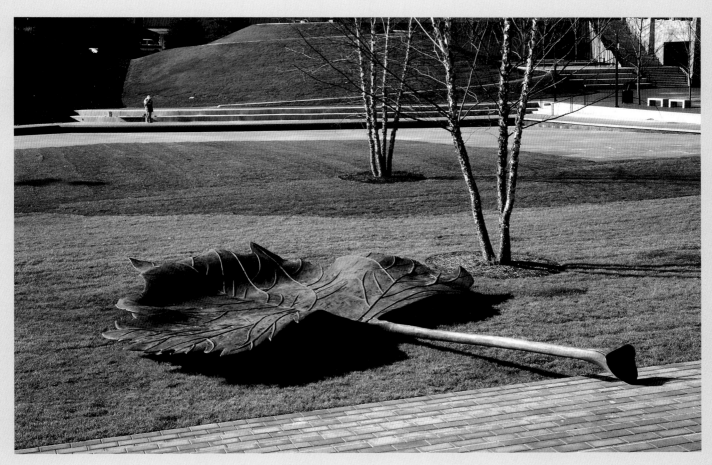

4

<2

heard about Walla Walla Foundry through Jim Dine. I was thinking about doing sculpture at the time. My paintings were getting so thick that I finally decided I needed to do them in relief. And the relief idea just popped off onto the floor, and we had sculpture.

Mark loves the creative spirit—watching things develop from a drawing or from an idea all the way through to completion. He's a real dreamer. But he also has a definite "can do" attitude; he makes you think that anything can happen there. He has a work force that is so dedicated and hardworking and strong; they are able to work through any problem. In fact, I think they really like the problems; that's the creative part for them.

When I went to the foundry it was like a playground for me, all those materials . . . I had timbers lying around and chunks of all these plaster sculptures. And then you have Jim Dine's things and Debby [Butterfield]'s things all around. It was a very exciting place to be, really like a playground for artists.

I did some pieces that were made out of cardboard, which would burn out. They were like cardboard reliefs that I was then going to paint. I mean, being a painter, I had to throw some paint on it. And doing these cardboard reliefs was tons of fun, and it was basically like drawing. So I started looking at this stuff much more like a drawing. You could work on it really quickly, using a hot-glue gun and cardboard, or sticks, or any kind of dispensable things. And you could take it down and then prop it back up. And if you liked it, good, and if not, then you could hack it; and if you changed your mind, you could put things back on with the glue gun. And then when you're done, you just mold it and cast it. The temporal look of it was then made permanent by the fact that it was now in bronze.

It was a perfect remedy for what I was trying to do. Going to the foundry and making sculpture has really helped my whole concept of art-making . . . has made it a rounder and fuller experience. Mark provides a workplace, a playground, to come and do stuff and see what can happen. It's not about the finished product so much as just letting you roam. He understands how artists work. It's not like making something and then just sending it off to be cast, like baby shoes. Especially for me, it was more about having the time to develop something. I spent a month at a time up there. And I couldn't get out of the foundry before midnight. After six I would kind of have time to myself. So, from six to midnight, I'd just sit there with a glass of Walla Walla wine, trying to figure out what to do next.

A lot of times, I would get there and everything would change because the place had such a strong influence on me. One time I saw these sunflowers that grow up there, and we always brag about everything being bigger in Texas, but those were the biggest sunflowers I had ever seen. I don't know if it's Hanford or what, but there are some sunflowers up there that are as big as garbage can lids. They're scary. I saw those and said, "Oh, that's something I've got to work with." And so we made sculptures.

David Bates, *born 1952, Dallas, Texas; BFA and MFA, Southern Methodist University; lives in Dallas*

Bates's multihued paintings, prints, and sculptures are infused with his keen knowledge of art history and familiarity with the southern folk art tradition. He creates expressive, colorful artworks inspired by the wildlife of Texas and Arkansas, a recurring theme being the fundamental interrelationship of man and nature.

1) *Woman in Studio*, 1994; 2) *Man with Pipe*, 1996;
3) *Irises and Tulips II*, 1999; 4) *Sunflowers and Thistles Still Life*, 1998–99; 5) *Shrimp and Beer*, 1994;
6) *Magnolia Branch*, 1998

1 >

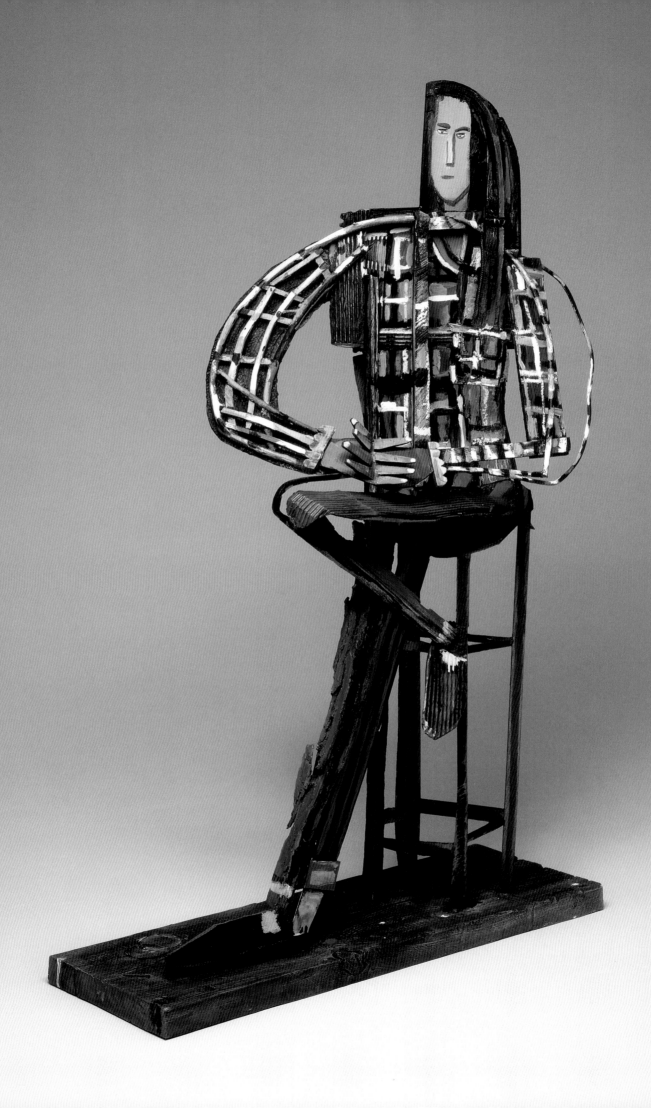

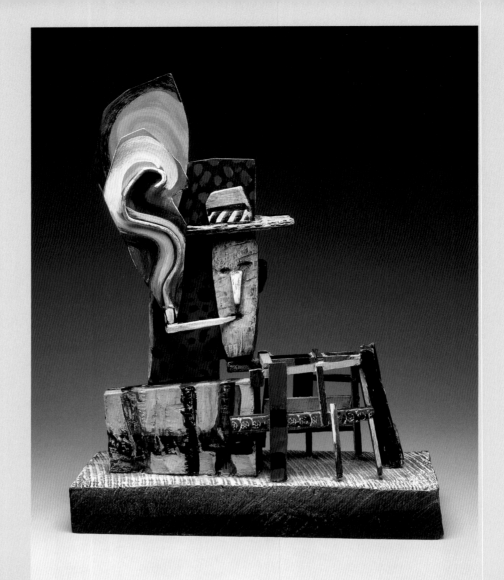

2

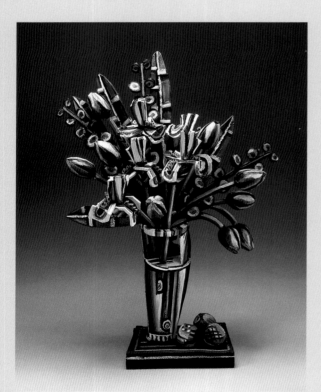

3

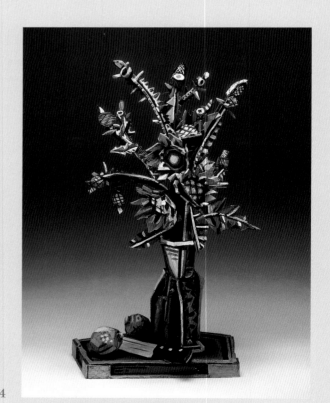

4

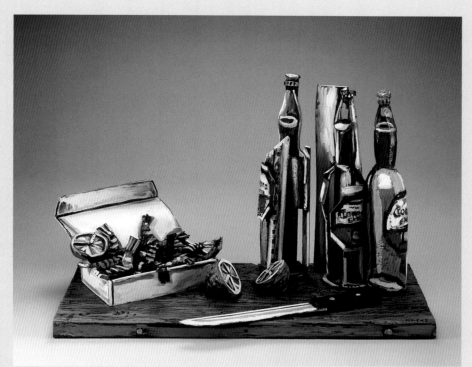

5

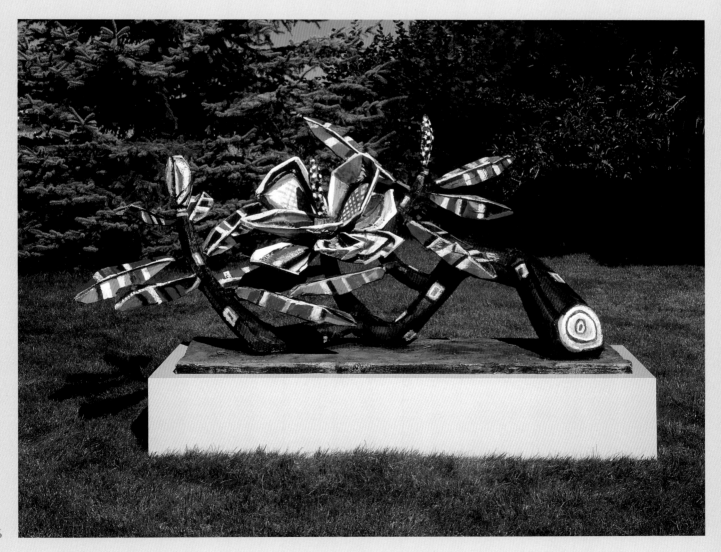

6

MARILYN LYSOHIR

n the 1980s, I was invited to be an artist in residence at Kohler, in Wisconsin—the bathtub mecca of the world. I wanted to do some large porcelain casting, but realized when I got there that it would be almost impossible to do something like an 8-foot porcelain casting there, and they said, "Why don't you try it in iron?" I knew nothing about sand-casting in iron, but I thought, well, this might be a good idea, so I made a model of an 8-foot bear.

I knew about the Walla Walla Foundry, so when I got back from Kohler, I met with Mark. I told him what I was doing and that it was sand-casting. He talked to me about it, but couldn't help me; they do lost-wax casting. But he gave me the time and told me so much about the casting process. So I went back to Kohler, loaded up with the information I had from Mark, and we made an iron bear. It was amazing. It was the biggest thing they had ever done at Kohler.

Later that summer, at a dinner given by the Kienholzes, I was waiting in line for sausages or something, and Mark came up and said, "How would you like to do a bronze bear?" And I thought, "Ooh, that would be wonderful." I didn't know what he was getting at, but he had a trade-off in mind: he wanted me to design the bathroom in his new home and in exchange he would do a bronze bear. Plus, he wanted to see if sand-casting was something they could do.

So they sand-cast the bear, using my molds from Kohler. And then I think they did a couple of things for John Buck. But Mark realized that the sand-casting surface quality was too limiting; it wasn't the way to go for most of the artists he worked with. It was short-lived, but it shows how they are open to everything. Mark is a nonlinear thinker. If you bring up sand-casting, he is going to try it to see if it's something they can do, to help all their clients. He is so supportive of all his artists.

Working in bronze changed my work. It changed in terms of scale, of course; you can't work that large in ceramics. But also, I had always worked by myself, made everything by myself. Working at the foundry was different. I could show them what I wanted and they made it for me. It saved me energy and time, and just wear and tear on my body. I thought, "Wow, this is the way to go!" And I felt really privileged to work there. I was a young artist at the time, in my thirties, and Jim Dine would be working there, and I just thought, "This is art history in the making."

Mark gave me a chance and believed in me as an artist; and I owe him. So when the bear sold, instead of buying a new car, I reinvested with Mark and did some more bronze works. And when Ross [Coates] and I started *High Grounds* (a journal to celebrate regional creativity), we chose Walla Walla Foundry as a focus for the first issue.

Where in the world would you ever have the meeting of all these artists in such a tiny little spot? It's not New York City, it's not LA; it's Walla Walla, Washington. There are areas like this spotted throughout the country, but if no one ever writes about them or documents them, then they're just like trees falling in the forest . . . Walla Walla Foundry is one of those places that people should know about—they should read about it and have it in their memory.

Marilyn Lysohir, *born 1950, Sharon, Pennsylvania; BFA, Ohio Northern University; MFA, Washington State University; lives in Moscow, Idaho*

Lysohir works primarily with ceramics that are glazed or painted in strong, bright colors. Her oversize sculptures disturb the audience's sense of scale and form, dazzling viewers with their vibrant colors. Her work often incorporates contradictions, for example, playing the poetic associations of surface decoration against sculptural form, instilling the work with controversial political or personal content.

1) *The Tatooed Lady and Dinosaur Series*, 2000;
2) *Last Immigrant Installation*, 1991

1 >

58

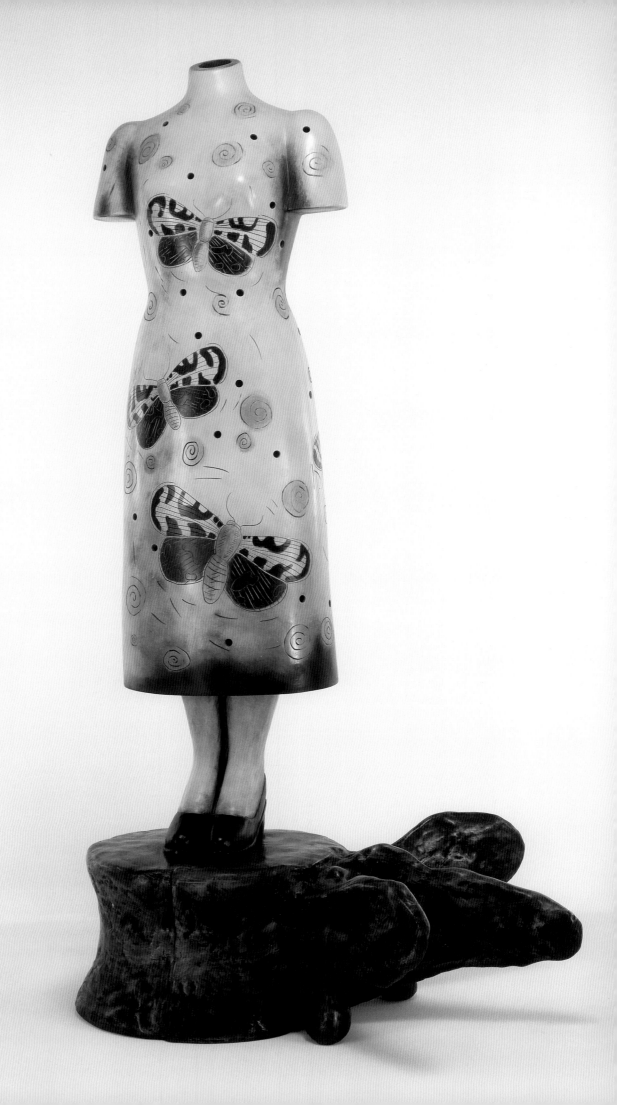

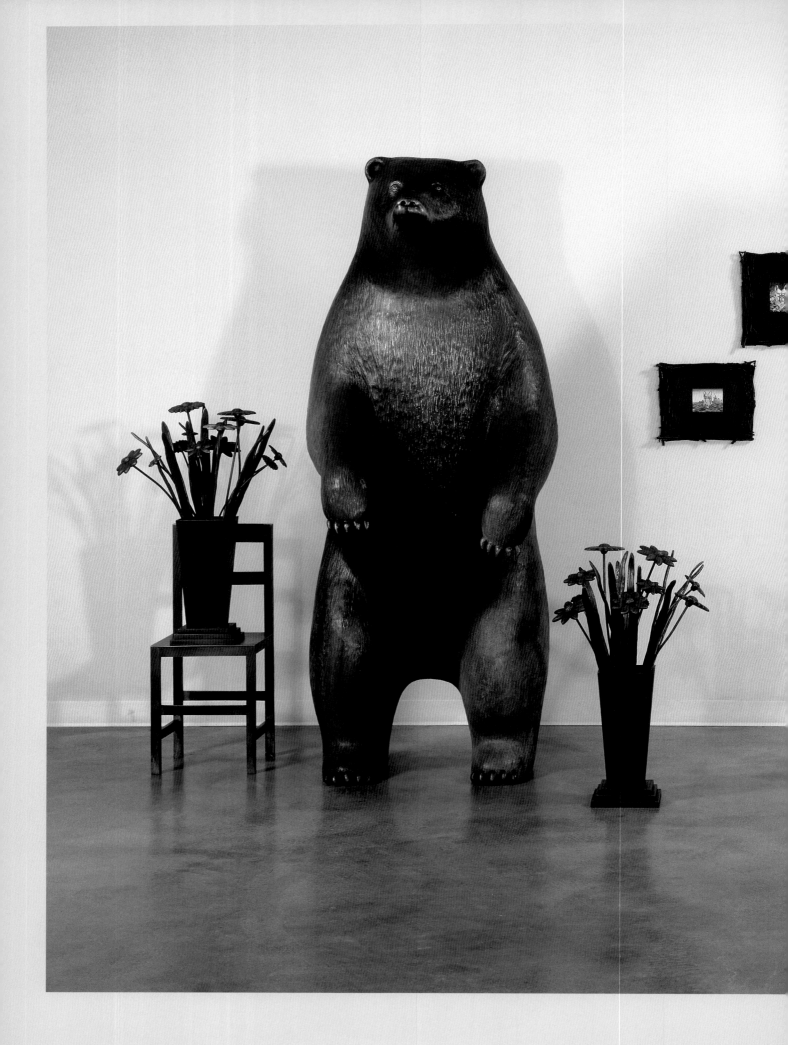

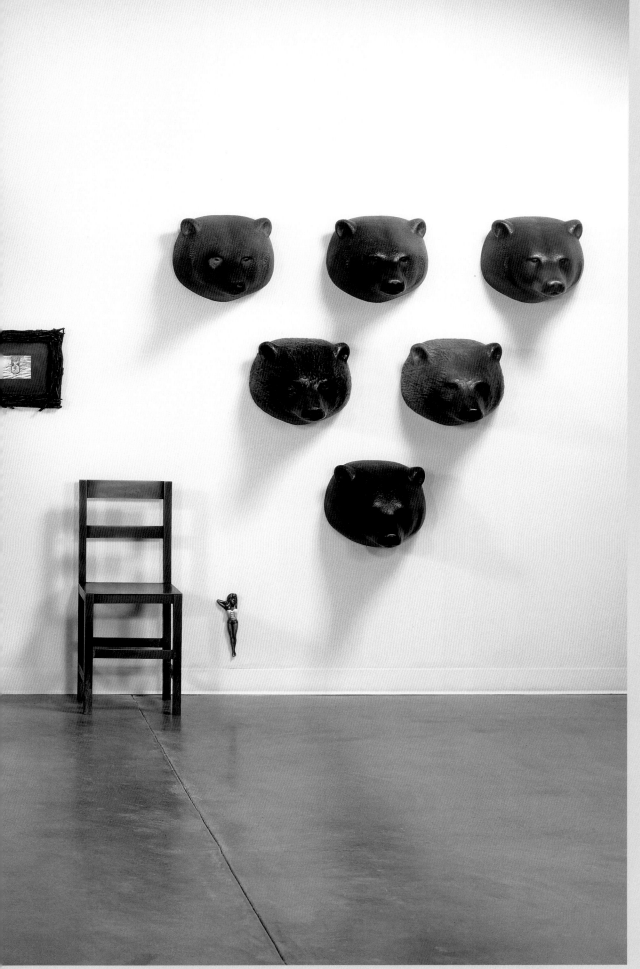

Roy Lichtenstein, *Metallic Brushstroke Head*, 1994

OPPOSITE: Roy Lichtenstein, *Brushstroke Chair and Ottoman*, 1986–88

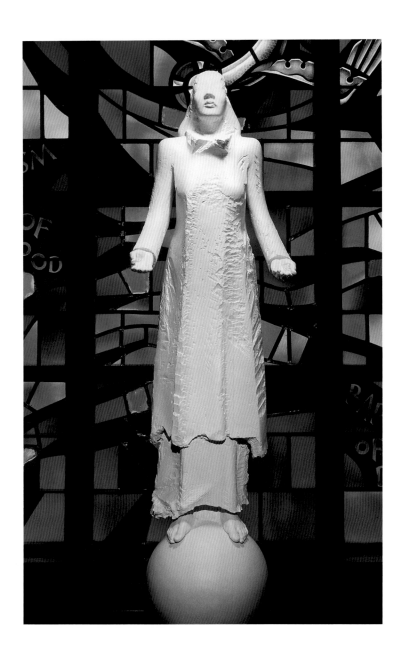

Manuel Neri, *Virgin Mary*, 2003

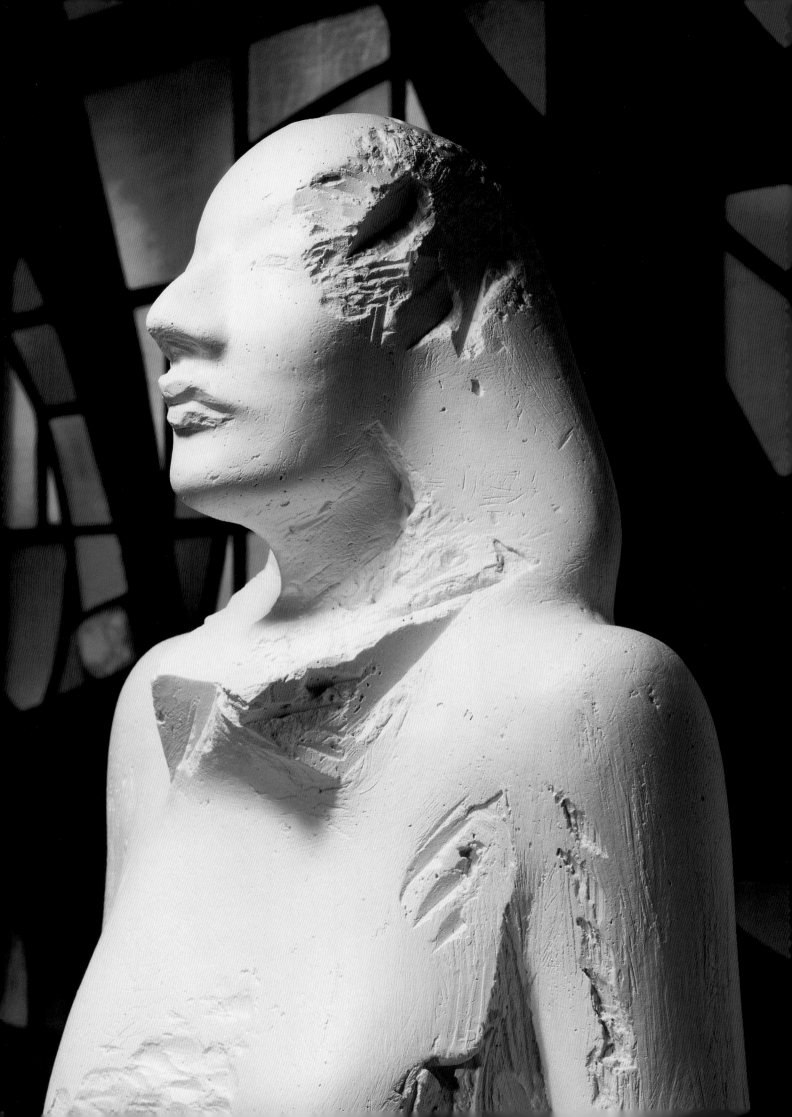

Nancy Graves, *Metaphore and Melanomy*, 1995

Nancy Graves, *Unending Revolution of Venus, Plants, and Pendulum*, 1992

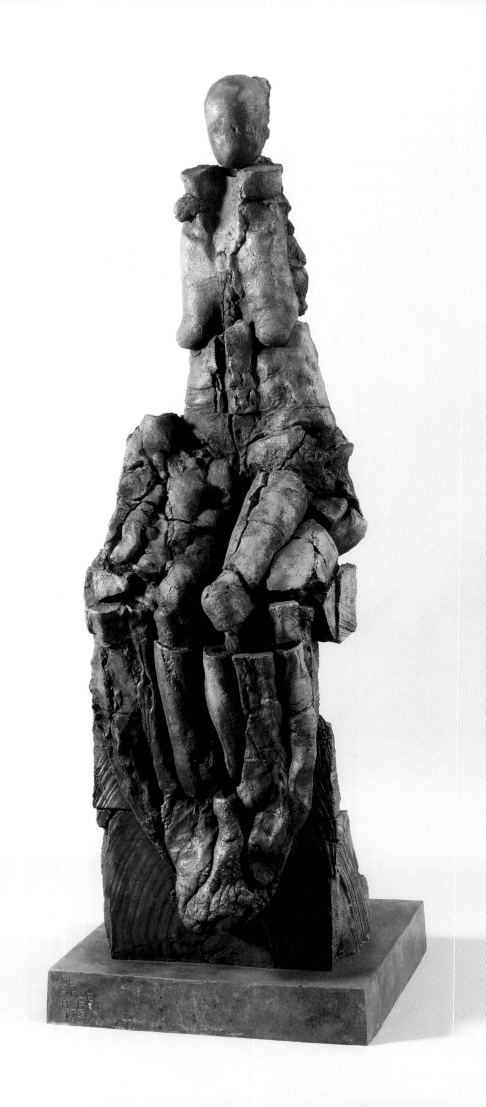

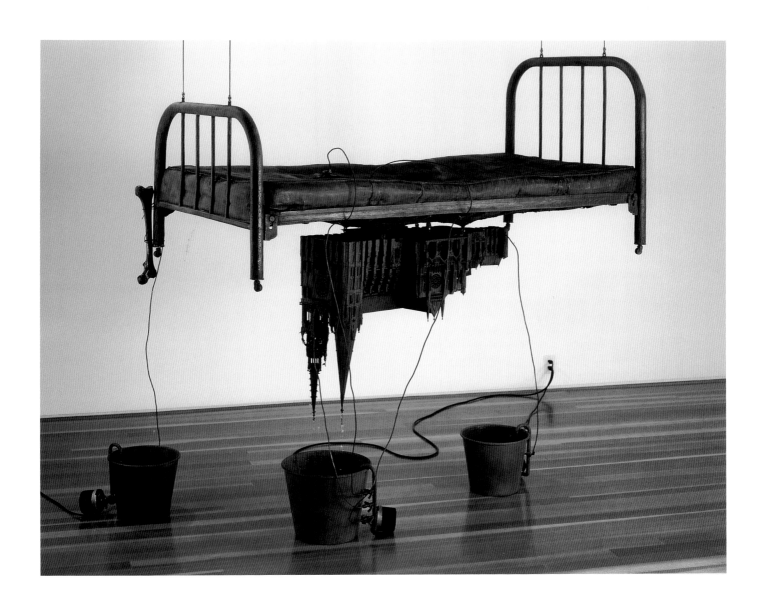

Stephen De Staebler, *Seated Woman with Oval Head*, 1981 Peter Shelton, *churchsnakebedbone*, 1993

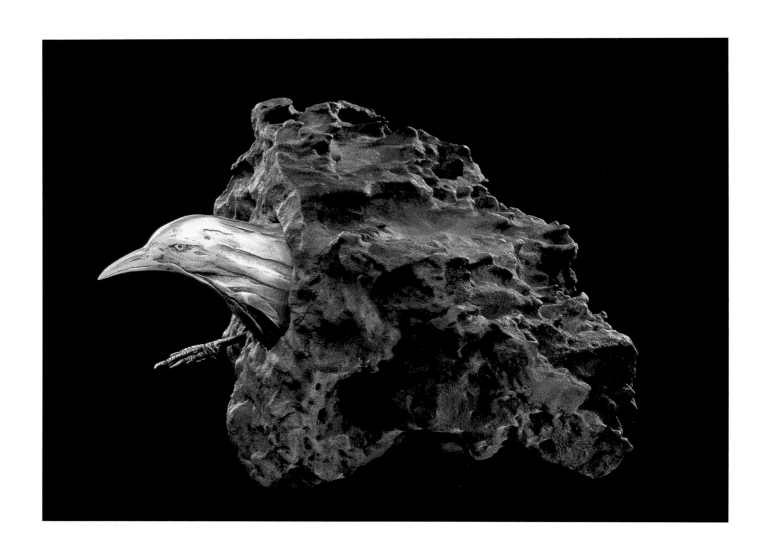

Frank Boyden, *Meteor*, 1992

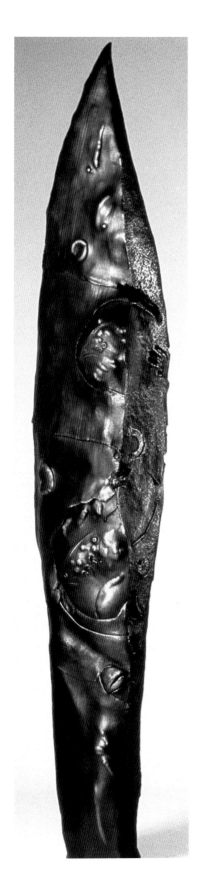
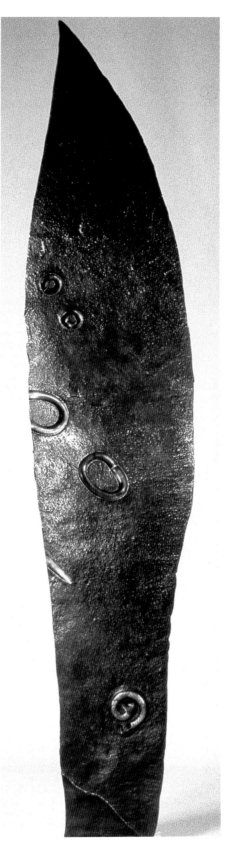
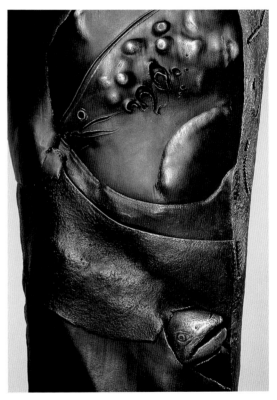

Frank Boyden, *Columbia Blade*, 1991

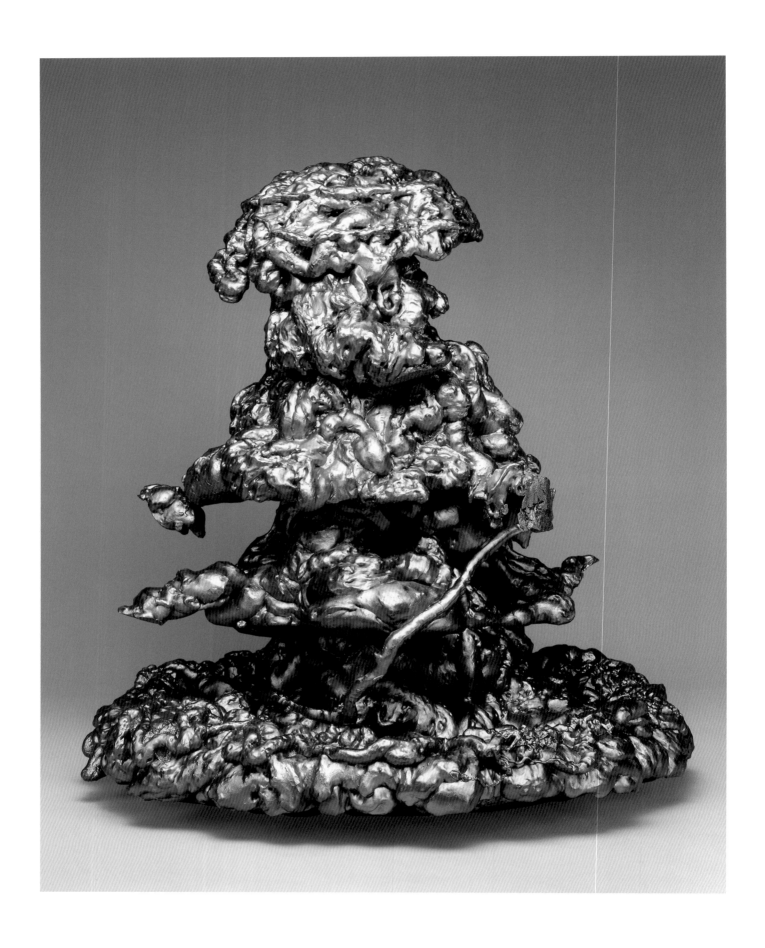

Lynda Benglis, *Summer Dreams*, 2003

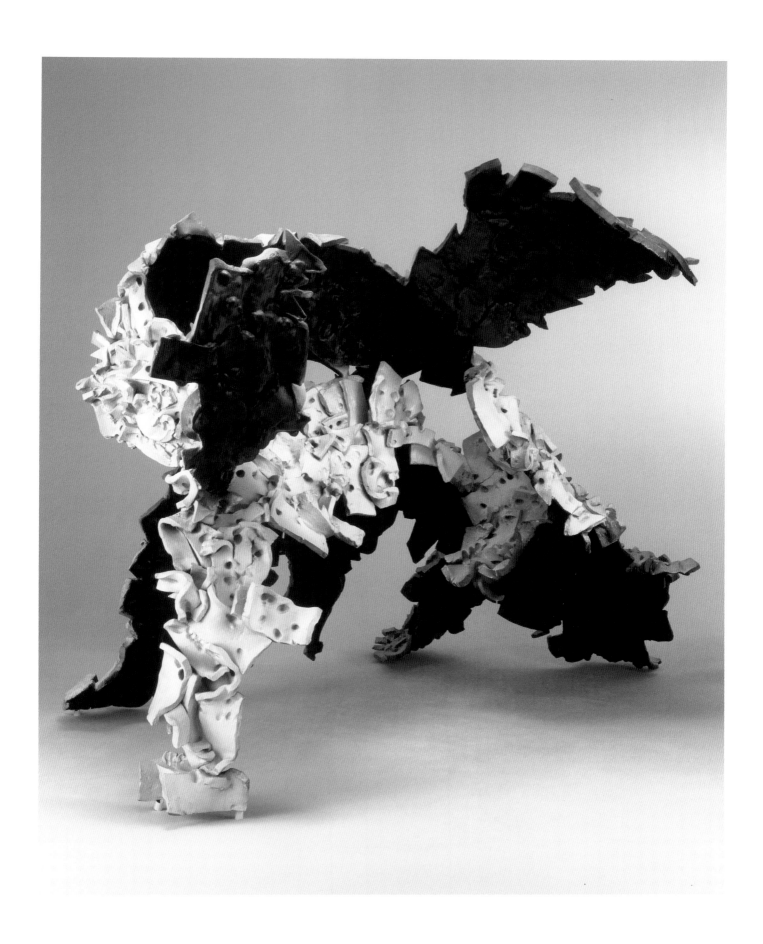

Lynda Benglis, *Migrating Pedimark*, 1998

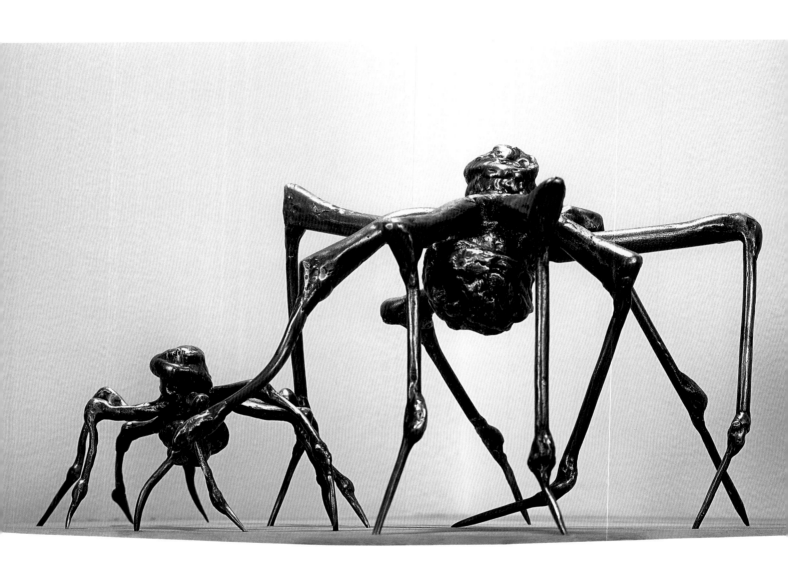

Louise Bourgeois, *Spider Home*, 2002

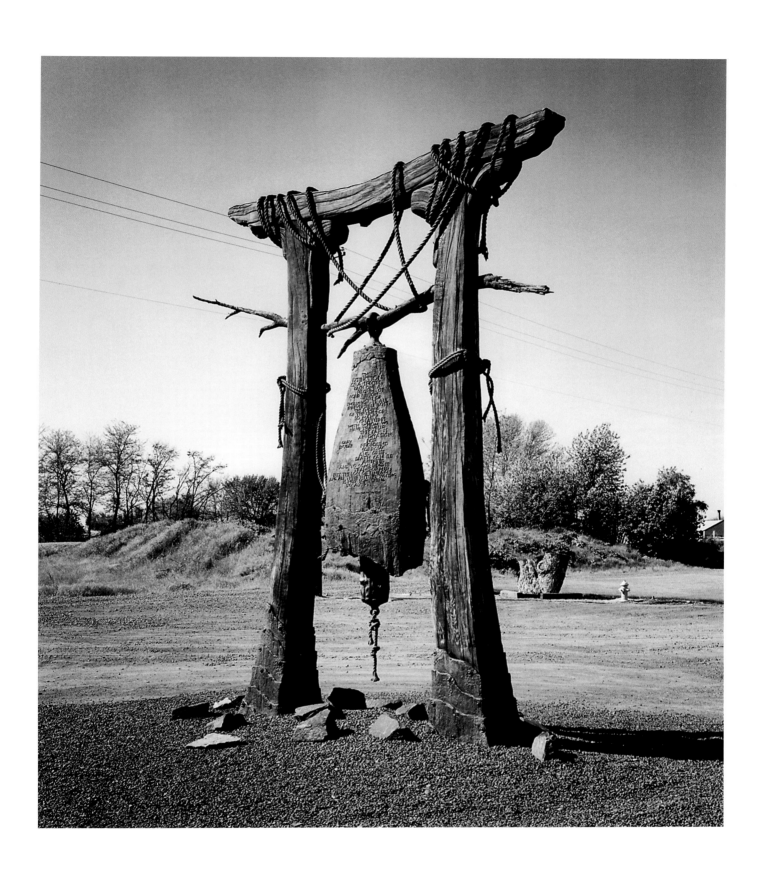

Wayne Chabre, *Wailing Bell*, 1996

Dallas Anderson, *Love without Condemnation*, 1984

Ming Fay, *Ginkoberry Gwa*, 2003
Installed at the Oregon Convention Center, Portland

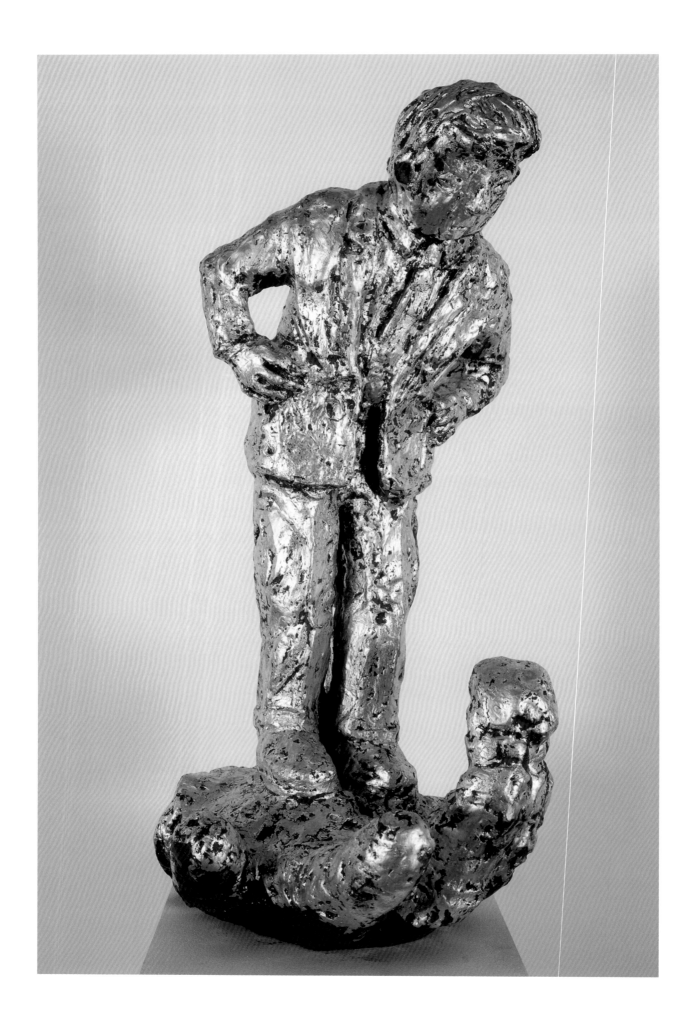

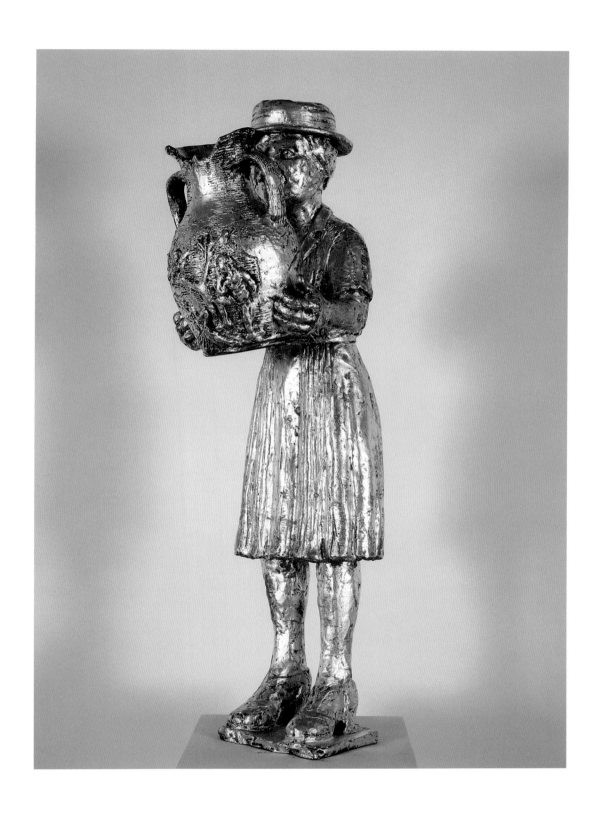

Viola Frey, *Man on Glove*, 1985 Viola Frey, *Grandmother/Wedgewood Portland Vase*, 1987

Ed Kienholz and Nancy Reddin Kienholz,
Mine Camp, 1991

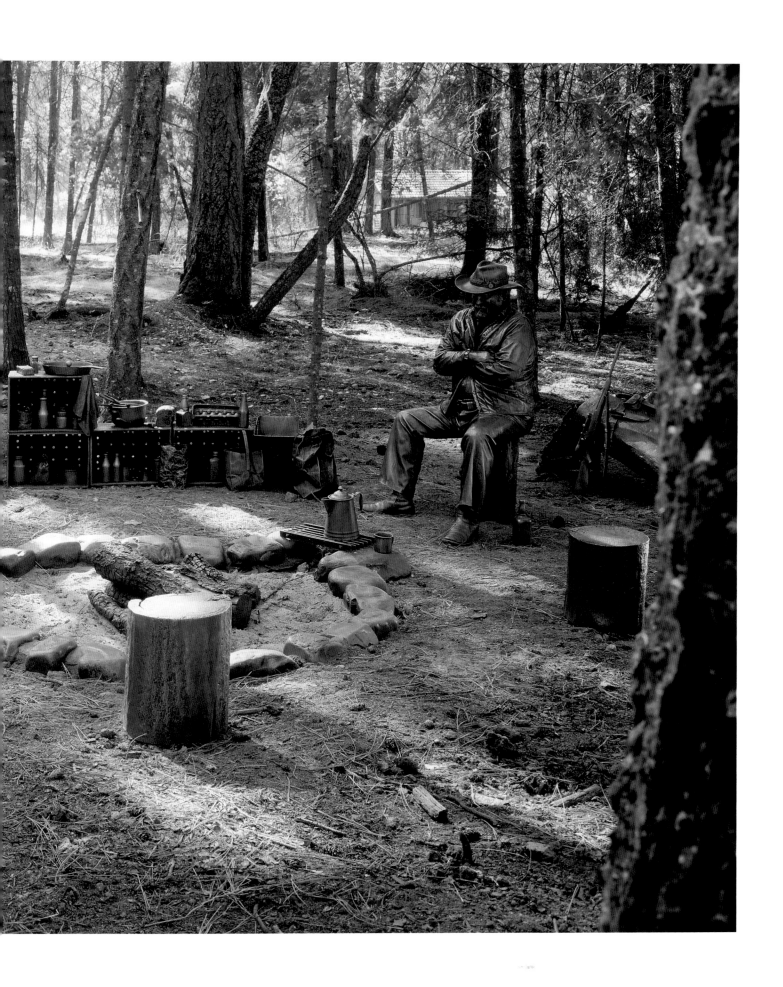

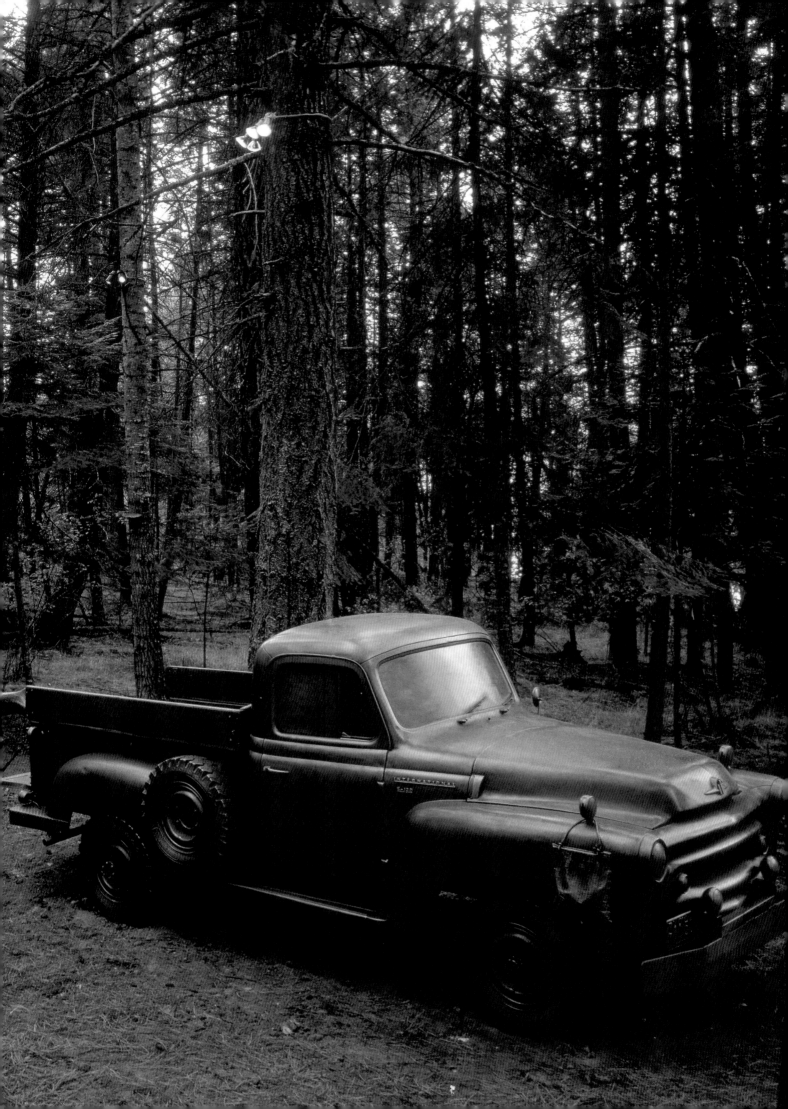

Sharon Kopriva, *Rites of Passage*, 1993

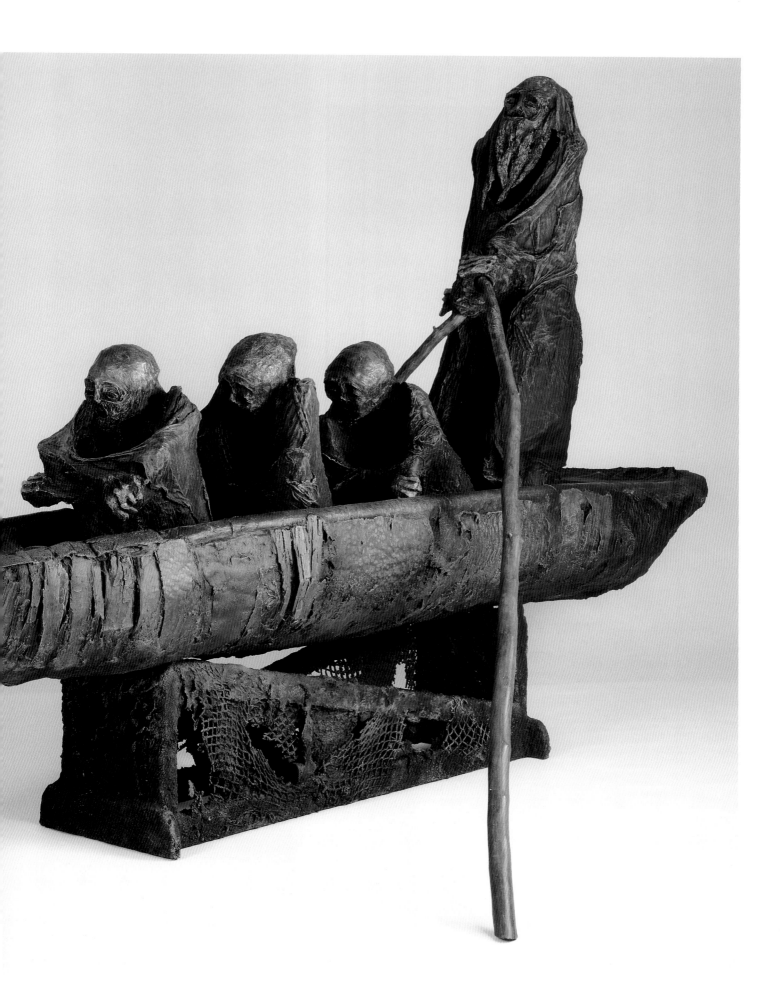

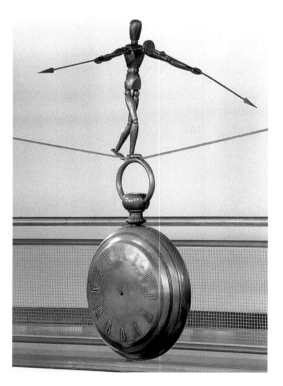

LEFT AND TOP RIGHT: Larry Kirkland, *Facing Future*, 2002

BOTTOM RIGHT: Larry Kirkland, *To Balance*, 2003

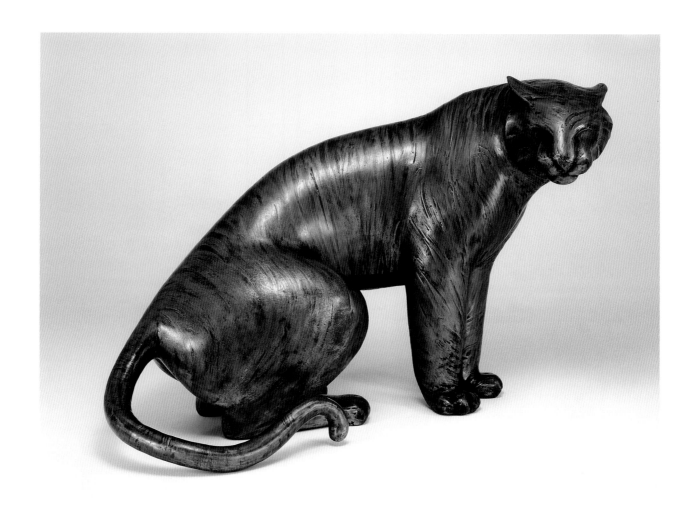

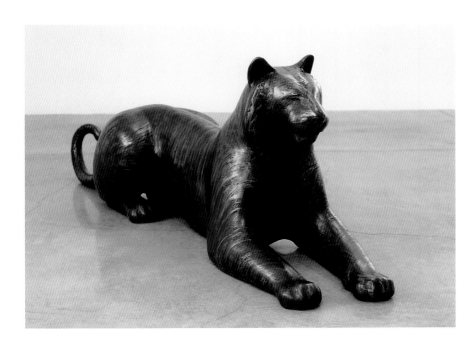

TOP: Gwynn Murrill, *Tiger 2*, 2002

BOTTOM: Gwynn Murrill, *Tiger 5*, 2002

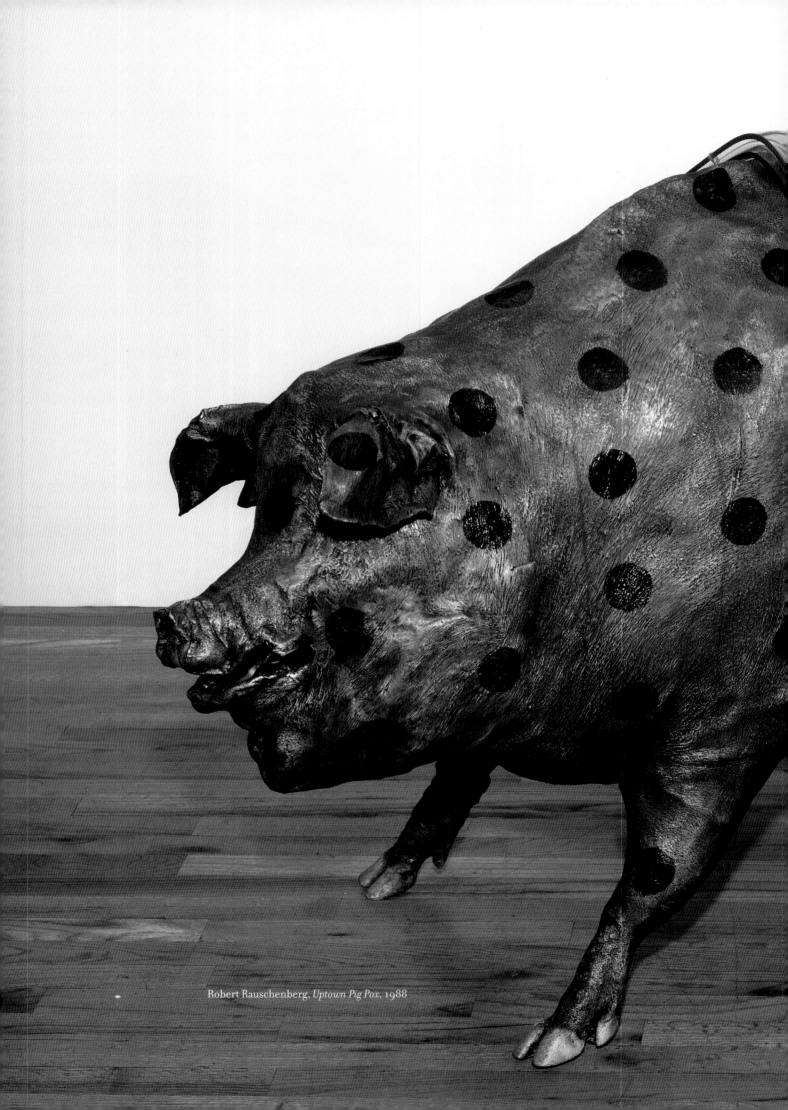

Robert Rauschenberg, *Uptown Pig Pox*, 1988

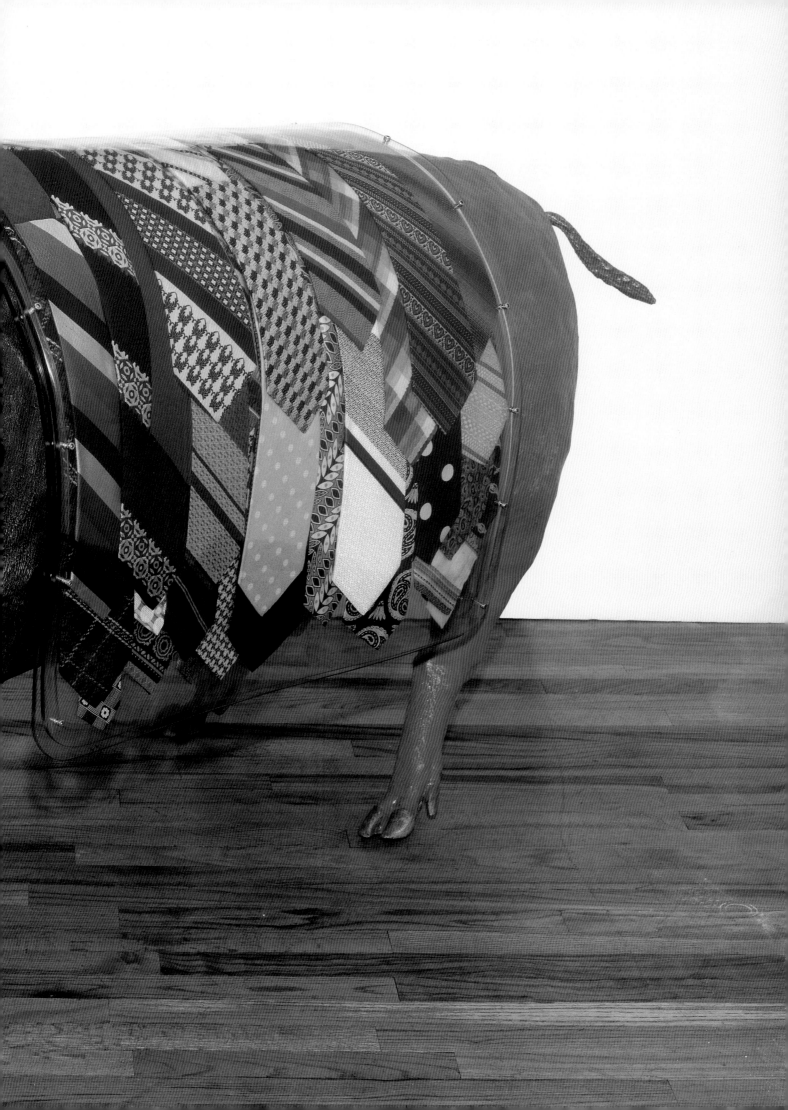

Christine Bourdette, *Voracious*, 2000

Carolyn Olbum, *Embrace*, 2000

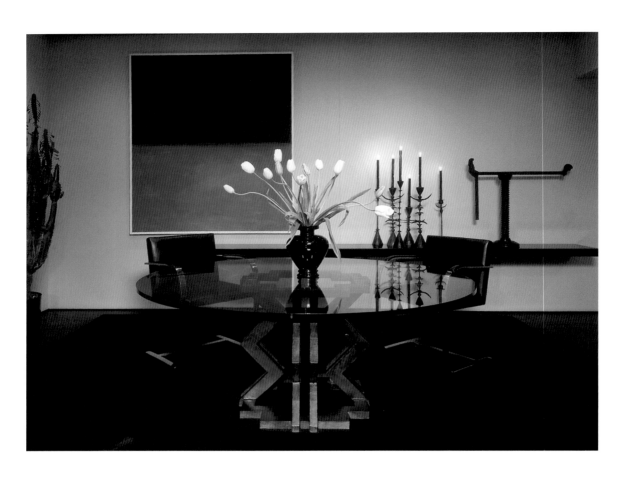

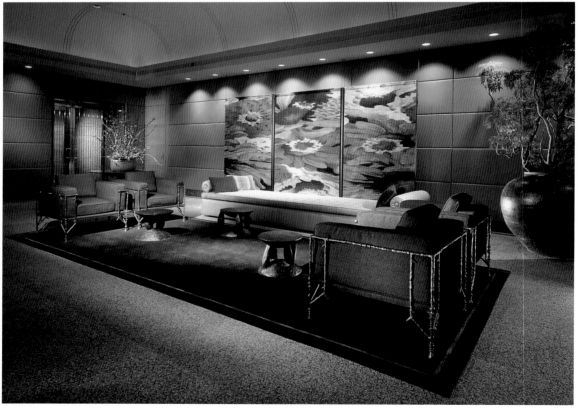

TOP: Gene Summers, *F-17 Table Base*, 1985

BOTTOM: Gene Summers, *Bronze Furniture*, 1992–93

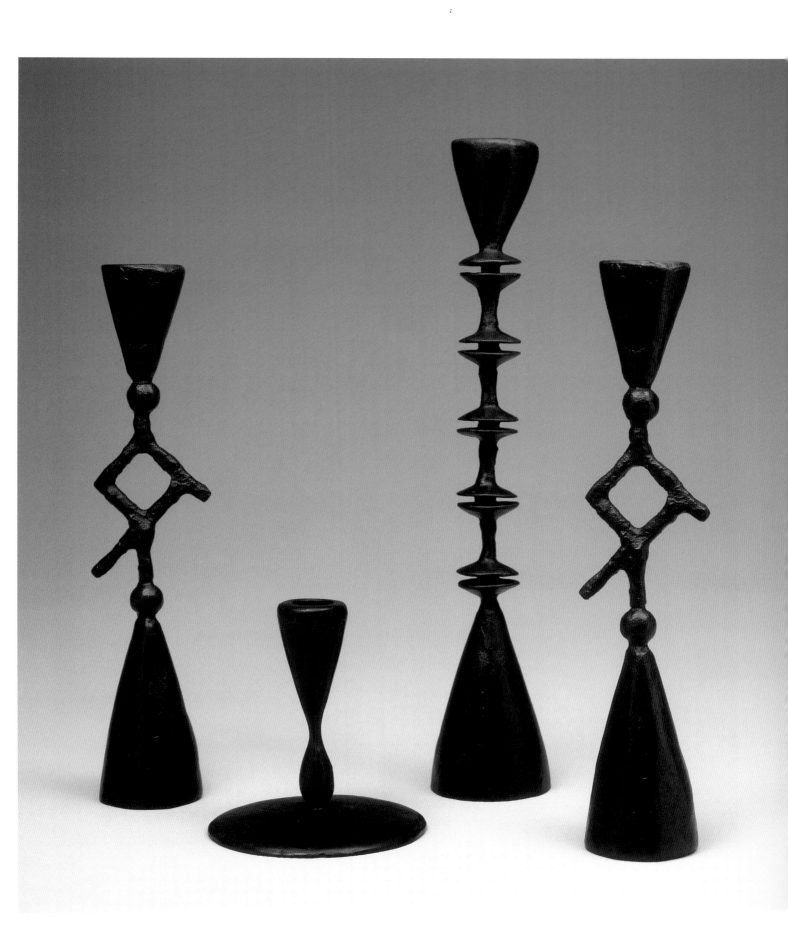

Gene Summers, *Candlesticks, C50, C56, C53, C50*, 1998

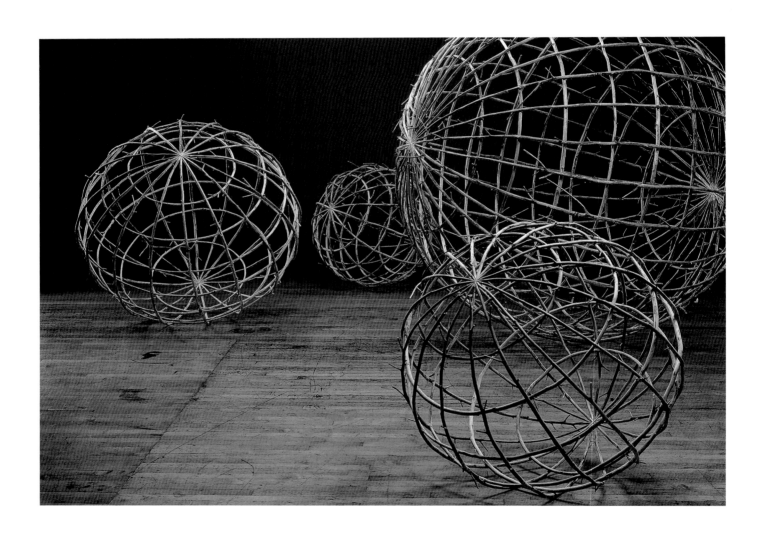

Joey Kirkpatrick and Flora Mace, *Sylvic Spheres*, 2002

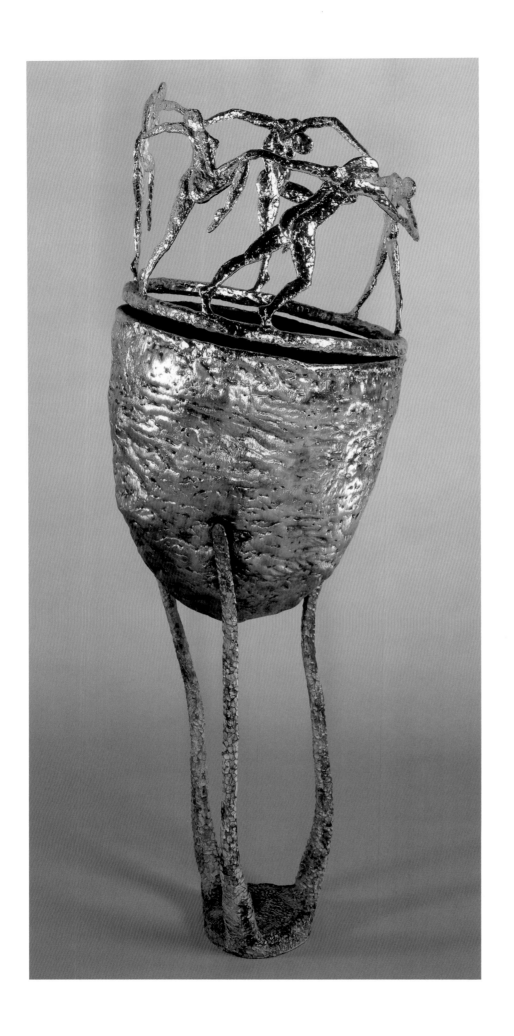

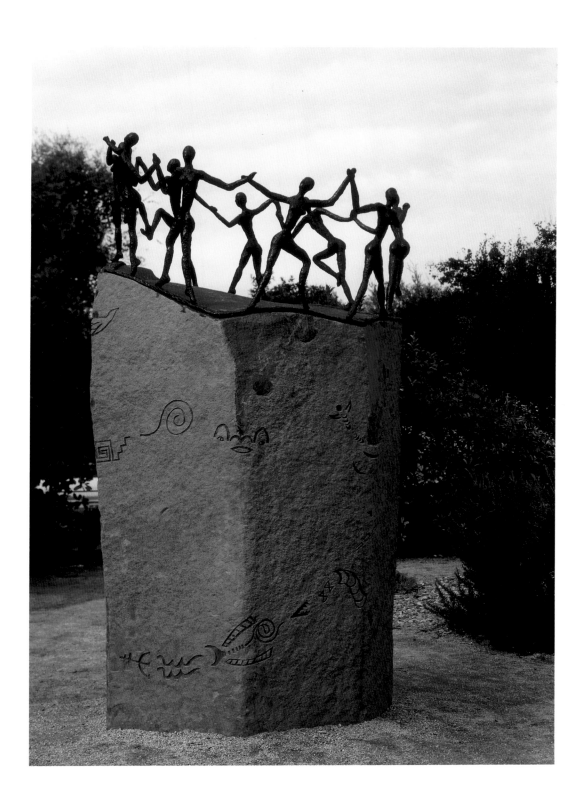

Sandra Shannonhouse, *The Witches M*, 1986

Sandra Shannonhouse, *Cnawan Stone*, 1995

Squire Broel, *Lights of the Valley*, 2003

LEFT: Robert Arneson, *This Head Is Mine*, 1981

RIGHT: Robert Arneson, *Poised to Infinity*, 1991

Robert Arneson,
California Artist, 1983

June 1980 Mark and Patty Anderson found Bronze Aglow, Inc. in Walla Walla, Washington. The name will change to Walla Walla Foundry in 1988.

First artist to begin casting with the foundry is Manuel Neri, Benicia, California.

> Works reproduced in the catalogue *Manuel Neri* published in 1988 by John Berggruen Gallery, San Francisco; James Corcoran Gallery, Santa Monica; and Charles Cowles Gallery, New York.

Begin working with Robert Arneson, Benicia, California.

> Works reproduced in the catalogue *Robert Arneson: Self-Reflections* published in 1997 by the San Francisco Museum of Modern Art.

1981 Work with Stephen De Staebler, Berkeley, California.

> Works reproduced in the catalogue *Stephen De Staebler: The Figure* published in 1987 by Chronicle Books, Laguna Gloria Art Museum, and Saddleback College.

1982 Begin working with Sandra Shannonhouse, Benicia, California.

Begin working with Viola Frey, Oakland, California.

Catalogue *Casting: A Survey of Cast Metal Sculpture in the 80's* published by Fuller Goldeen Gallery, San Francisco; includes works by Manuel Neri, Robert Arneson, and Stephen De Staebler cast at Bronze Aglow.

1983 Begin working with Jim Dine, New York.

> Works reproduced in the catalogue *Jim Dine's Venus: Civico Museo Revoltella* published in 1996 by Electa, Milan.

Begin working with Robert Hudson, Petaluma, California.

1984 Begin working with Gene Summers, Los Angeles.

> Works reproduced in the book *Gene Summers: Art/Architecture* published in 2003 by Birkhäuser—Publishers for Architecture.

Purchase of Bryant Street building (3,200-square-foot facility) in Walla Walla.

1985 Begin working with Deborah Butterfield, Bozeman, Montana.

> Works reproduced in the book *Deborah Butterfield* by Robert Gordon, published in 2003 by Harry N. Abrams.

Begin working with Dallas Anderson, Westminister, California.

Purchase of 1904 historic buildings on 4.23 acres at 405 Woodland Avenue, Walla Walla.

1986 Begin working with Chuck Ginnever, Putney, Vermont.

Works reproduced in the catalogue *Charles Ginnever* published in 1987 by Anne Kohs & Associates, San Francisco.

Work with Robert Rauschenberg in conjunction with Graphic Studio, Tampa, Florida.

1987 Work with Roy Lichtenstein in conjunction with Graphic Studio, Tampa, Florida.

1988 Begin working with Marilyn Lysohir, Moscow, Idaho.

Spring Run installed at First Security Plaza, Boise, Idaho, in 1994.

Foundry renamed Walla Walla Foundry, Inc.

Receive civic Architectural Award for the renovation of a historic structure, the Walla Walla Iron Works building, which becomes part of the foundry's facilities on Woodland Avenue.

Selected bronzes from the collection of Walla Walla Foundry and private collections exhibited at Sheehan Gallery, Whitman College, Walla Walla.

Selected bronzes from the collection of Walla Walla Foundry exhibited at the Cheney Cowles Museum, Spokane, Washington.

1989 Begin working with Frank Boyden, Otis, Oregon.

Columbia Blade installed at Woodward Canyon Winery, Touchet, Washington, in 2002.

1990 Work with Ed Kienholz and Nancy Reddin Kienholz, Hope, Idaho.

Begin working with Shoichi Ida, Kyoto, Japan, in collaboration with Washington/Pacific: Cultural Connections.

1991 Begin working with Peter Shelton, Malibu, California.

Works reproduced in the catalogue *Peter Shelton: Bottlesbonesandthingsgetwet* published in 1994 in conjunction with an exhibition at the Los Angeles County Museum of Art, Los Angeles.

Begin working with Nancy Graves in conjunction with Saff Tech Arts, Tampa, Florida.

Works reproduced in the catalogue *Nancy Graves: Recent Works* published in 1993 by the Fine Arts Gallery, University of Maryland Baltimore County, Catonsville.

Receive civic Architectural Award for landscaping at the Walla Walla Foundry facility.

1992 March/April issue of *Sculpture* magazine features *Mine Camp* by Ed Kienholz and Nancy Reddin Kienholz, cast at the Walla Walla Foundry in 1991.

PBS Special "Behind the Scenes with Nancy Graves" filmed at the foundry.

Begin working with Brad Rude, Walla Walla.

Works reproduced in the catalogue *Brad Rude: Original Nature* published in 1998 in conjunction with an exhibition at the Holter Museum of Art in Helena, Montana.

Begin working with Vladimir Tsivin, a visiting artist from St. Petersburg, Russia.

Begin subsidiary business, FarWest Materials, to sell sculpture and mold-making supplies and materials by mail order, online, and to local artists.

1993 Begin working with Terry Allen, Santa Fe, New Mexico.

Belief installed at the University of Cincinnati Vontz Center for Molecular Studies, Cincinnati, Ohio, in 1999.

Mark Anderson is the recipient of the Pete Reid Award for Young Alumni for exemplifying spirit, commitment, and outstanding contributions to his profession and community; award presented by Whitman College President Tom Cronin.

Work with Sharon Kopriva, Houston, Texas.

Exhibition *Sculpture of Artists Who Cast at the Walla Walla Foundry* presented at the Greg Kucera Gallery, Seattle.

1994 Begin working with David Bates, Dallas, Texas.

Works reproduced in the catalogues *David Bates: Roughshod*, published in 1994 by John Berggruen Gallery, San Francisco, and *David Bates: Black & White*, published in 2001 by Dunn and Brown Contemporary, Dallas.

Begin working with John Buck, Bozeman, Montana.

Works reproduced in the catalogue *John Buck: Recent Sculpture and Woodblock Prints* published in 1999 in conjunction with an exhibition at the Gallery of Contemporary Art at Lewis and Clark College, Portland, Oregon.

Begin working with Tad Savinar, Portland, Oregon.

1995 Featured in *High Ground*, an art journal published by Marilyn Lysohir and Ross Coates, Moscow, Idaho.

Begin working with Carolyn Olbum, Ketchum, Idaho.

1996 Walla Walla Foundry/Mark and Patty Anderson are recipients of one of three Governor's Arts Awards given for significant contribution to art and culture by the Washington State Arts Commission; award is presented by Governor Mike Lowry.

Begin working with Dana Louis, Portland, Oregon.

Tree of Knowledge installed at the Central Library in Portland, Oregon, in 1997.

1997 Work with James Cutler and Maggie Smith, Bainbridge Island, Washington.

Casting of Armed Forces Memorial, which is installed in Norfolk, Virginia, and reproduced in the book *James Cutler* published in 1997 by Rockport Publishers (Contemporary World Architects series).

Work with Bill Will, Portland, Oregon.

Everyday Hero installed at Fire Station No. 12, Portland, Oregon, in 2002.

Work with Squire Broel, Walla Walla.

Work with Jindra Vikova, a visiting artist from Prague, Czech Republic.

Begin working with Larry Kirkland, Washington, D.C.

Works reproduced in the book *Larry Kirkland: Twenty-five Years* published in 1999 by LightWater Press.

Work with Tom Otterness, New York.

Cast Contemporary Sculpture, an exhibition of works from the Walla Walla Foundry, presented at Whitman College, Walla Walla.

1998 Work with Lynda Benglis, Santa Fe, New Mexico.

Casting of bronze fountain *Summer Dreams*, which is reproduced in the catalogue *Lynda Benglis* published in 2004 in conjunction with an exhibition at Chem & Reid, New York.

Work with Wayne Chabre, Walla Walla.

1999 Studio B, a 40-foot building, is built on the complex to accommodate larger sculptures.

Work with Judy Pfaff, New York.

Installation of *Yû-Wa* commission for ODS Tower, Portland, Oregon.

2000 Purchase of fabrication business and begin operation of Walla Walla Fabrication & Design.

Work with Christine Bourdette, Portland, Oregon.

As part of the foundry's twentieth-anniversary celebrations, present an exhibition of outdoor sculptures by David Bates, Frank Boyden, John Buck, Deborah Butterfield, Jim Dine, and Charles Ginnever.

2001 Begin designs for CNC milling machine equipment for digital operations.

Work with Joey Kirkpatrick and Flora Mace, Seattle, Washington.

Work with Gwynn Murrill, Los Angeles.

2002 Fabricate the first digital operations project with Jim Dine: a 2-foot *Venus* model enlarged to 37 feet in foam, cast in bronze, installed in 2003 in the rotunda of the Carl B. Stokes Federal Courthouse in Cleveland, Ohio.

Begin working with Ming Fay, New York.

2003 Fabricate the second digital operations project with Ming Fay: *Ginkgoberry Gwa*, a 1-inch ginkgo nut enlarged to 6 feet plus a 6-foot stem (two made); installed at the Oregon Convention Center, Portland.

Work with Louise Bourgeois in conjunction with Graphic Studio, Tampa, Florida.

Walla Walla Public School District presents the Graduates of Distinction Award to Mark Anderson for his distinguished achievements.

2004 Opening of the Walla Walla Foundry Gallery in May.

Exhibition at the Museum of Art at Washington State University of works by Jim Dine and sculpture from the Walla Walla Foundry.

Avenue of the Americas, New York: Jim Dine, *Looking Toward the Avenue*, 1989

Berkeley Square, London, England: Jim Dine, *Venus for Broadgate*, 1989

Carl B. Stokes Federal Courthouse, Cleveland, Ohio: Jim Dine, *Cleveland Venus*, 2003

Château Smith Haut Lafitte, Bordeaux, France: Jim Dine, *Bordeaux Venus*, 2002

Civic Center Building, City of Denver, Colorado: Larry Kirkland, *East and West*, 2001

Doernbecher Children's Hospital, Oregon Health Sciences University, Portland, Oregon: Frank Boyden and Brad Rude, Collaborative Commission, 1995–98

Fire Station No. 12, Portland, Oregon: Bill Will, *Everyday Hero*, 1997

George Bush Intercontinental Airport, Houston, Texas: Terry Allen, *Countree Music*, 1999

Guggenheim Museum, Bilbao, Spain: Jim Dine, *Three Red Spanish Ladies*, 1997

Israel Museum, Jerusalem, Israel: Jim Dine, *Crommelynck Gate with Tools*, 1984

Lake Pend Oreille, Hope, Idaho: Ed Kienholz and Nancy Reddin Kienholz, *Mine Camp*, 1991

Lewis and Clark College, Portland, Oregon: John Buck, *The Hawk and the Dove* and *Music in the Sky*, 1999

National Gallery of Art, Washington, D.C.: Nancy Graves, *Clock: Unending Revolution of Venus, Plants, and Pendulum*, 1992

Oregon Convention Center, Portland, Oregon: Ming Fay, *Ginkgoberry Gwa*, 2003

Portland International Airport, Portland, Oregon: Deborah Butterfield, *Lyon, Silverfork & Princess Pine*, 1995

Saint Anne's Parish, Seattle, Washington: Manuel Neri, *Virgin Mary*, 2003

Texas Tech University, Lubbock, Texas: Terry Allen, *Read Reader*, 2002

United States Courthouse, Seattle, Washington: Ming Fay, *Pillar Arc*, 2004

University of California, Davis: Robert Arneson, *Egghead Series*, 1991–92

University of Cincinnati Vontz Center for Molecular Studies, Cincinnati, Ohio: Terry Allen, *Belief*, 1999

Utica, Montana: Tom Otterness, *Makin' Hay*, 2002

Western Washington University, Bellingham, Washington: Tom Otterness, *Feats of Strength*, 1999

Whitman College, Walla Walla, Washington: Jim Dine, *Carnival*, 1997; and Deborah Butterfield, *Styx*, 2002

Note: Words in italics refer to other terms in the glossary.

ALLOY: A metallic material formed by mixing two or more elements; usually its properties are different from those of the individual components.

BACKING: Plaster with sisal placed on the backside of a wax form that helps the wax hold its shape when removed from a rubber *mold* and also assists during transporting and spray coating.

BINDER: A material used to hold the grains of sand together in ceramic shell molds or cores.

BLIND RISER: An internal *riser*, which does not reach to the exterior of the *mold*.

BREAKOUT: The process of removing a *casting* from its *mold*.

BRONZE: A copper-based *alloy* with tin as the major alloying element.

BURNER: A device that mixes fuel to provide perfect combustion when the mixture is burned. Types of fuel include acetylene, oil, gas, powdered coal, stoker, and other combustible elements.

BURN-OUT: Removal of a wax or wood *pattern* in the plaster *investment* and *ceramic shell* processes by heating the *mold* to a sufficient temperature to consume any carbonaceous residues. Investment molds reach temperatures of 1100 degrees Fahrenheit, while ceramic shell molds reach temperatures of 1700 degrees Fahrenheit.

CARBIDE: A cutting tool made of carbide used to chase metal castings when placed in an air- or electric-driven grinder.

CASTING: Metal poured into a *mold* to form an object, or the act of pouring molten metal into a mold.

CAST-WELD ASSEMBLY: The process of welding one *casting* to another to form a complete assembly.

CERAMIC SHELL MOLDING: A *mold* in which *refractory* and colloidal silica *binder* are layered over a *pattern* and then fired at a high temperature until a rigid structure is formed.

CLEANING: The process of removing *investment*, *ceramic shell*, and surface blemishes from castings, by means of sandblasting or high-pressure water.

CNC: Computer Numeric Controlled.

COMPUTER NUMERIC CONTROLLED SYSTEM: The general term for the method used to run the foundry's carving machines. Software "communicates" with the motors, which power the movement of the carving machine via binary code. The carving tool is positioned with extremely accurate drive motors that move it to a given coordinate point in three-dimensional space.

CORE SHIFT: A defect resulting from movement of the core from its proper position inside the *mold* cavity.

CRUCIBLE: A receptacle of graphite clay or silicone graphite clay material in which metal is melted inside a crucible furnace.

DATA POINTS: The coordinate geometry assigned to the surface of a model in order to capture its geometric representation.

EXPENDABLE PATTERN: In *investment* casting, a wax or other burnable *pattern* is placed in a *mold* and later melted or burned out. Also called a disposable pattern.

FLASHING: A fin of metal protruding from a *casting* that results when molten metal flows into a crack in the *mold*.

FOUNDING: The art and science of melting and pouring metals and alloys into castings.

GATING SYSTEM: The entire assembly of connected gates used to carry metal from the top of the *mold* to the cavity of the mold that will create the *casting*.

INCLUSION: Particles of *slag*, sand, or other impurities trapped mechanically during solidification or formed by subsequent reaction of the solid metal.

INDUCTION FURNACE: A melting unit in which the metal charge is melted electrically by induction.

INGOT: A commercial block of copper, aluminum, or other nonferrous materials cast into a convenient shape for storage and transportation to be processed later.

INVESTMENT MOLDING: A method of molding using a *pattern* of wax, wood, or other material that is "invested" or surrounded by a molding medium in *slurry* or liquid form. After the molding medium has solidified, the pattern is removed by subjecting the *mold* to heat, leaving a cavity for reception of molten metal. Also called lost-wax process or precision molding.

KILN: A piece of equipment to burn out and cure *molds* using electricity, gas, or another source of energy to create heat.

LADLE: A metal receptacle lined with *refractory* for transportation of molten metal.

LEAKER: A foundry term for *molds* that leak under the pressure of liquid metal.

LINING: The inside *refractory* layer of firebrick, clay, sand, or other material in a furnace of *ladle*.

LOST-WAX PROCESS: See *investment molding*.

MOLD: The negative of an object created by encasing the object in rubber, supporting the rubber with a rigid *backing*, then removing the object. This type of mold is typically used to produce wax *patterns*, which are used to produce *castings*.

MULTI-AXIS CNC ROUTER: The foundry's carving machines, which use *CNC* routers that have the ability to move in multiple directions at the same time.

OPTICAL LASER SCANS: A method for gathering geometric information describing the surface of a model. A laser beam is directed at a model; the beam reflects off the surface and is received at two points. These points are triangulated and the distance from the origin of the laser to the reflective surface is calculated. This point, based on its distance (or depth) from the laser and its location within a planar grid, represents a coordinate, or *data point*.

OXIDATION: Any reaction whereby an element reacts with oxygen.

PARAMETER: The variables that define the physical limits of the foundry's scanner and carving machines.

PARTING LINE: The line along which an object is divided for molding or along which the sections of a *mold* are separated.

PATINA: The process in which chemicals are applied with heat, *oxidizing* the surface of a *casting* to create a desired color.

PATTERN: A model of wood, metal, plaster, wax, or other material used in making a *mold*.

POLYGONIZATION: The act of converting the *data points* gathered by the scanner into a solid model. The data points are employed as vertices, which are triangulated to form a solid model constructed out of a series of planes, or triangles.

POROSITY: Unsoundness in *castings* which appears as blowholes and shrinkage cavities.

POURING CUP: A cup-shaped depression in the top of an *investment* or *ceramic shell* mold that acts as a funnel to direct molten metal into the *gating system* of a *casting*.

REFRACTORY: A material, usually made of ceramics, that is resistant to high temperatures, molten metal, and *slag* attack.

RISER: A reservoir of molten metal attached to the *pattern* to compensate for internal contractions of the *casting* during solidification.

SANDBLAST: A stream of sand projected by compressed air, which when directed at *castings* using a nozzle cleans the oxides and molding compounds off them.

SILICONE BRONZE: A series of *alloys* containing 1–5% silicone, 91–94% copper, and less than 5% zinc, along with trace elements of manganese, iron, and lead.

SKIMMER: A device or tool for removing *slag* and dross from the surface of molten metal.

SLAG: A nonmetallic covering of molten metal that results from the combining of oxygen and the impurities contained in the original charge and any silica and clay eroded from the *refractory* lining or *crucible*.

SLURRY: A liquid coating of colloidal silica and *refractory* used as a *binder* in the *ceramic shell* process.

SPRUING: The act of adding gates, vents, and *risers* to a wax *pattern* to create a *gating system*.

VENT: An opening in a *mold* or core to permit the escape of air and gases.

WALLA WALLA FOUNDRY STAFF

Mark A. Anderson, Managing Director
Patty Anderson, Human Relations Director
David M. Anderson, Administrative Accountant
Byron Peterson, Production Manager
Dylan Farnum, Digital Operations

MUSEUM OF ART/WSU STAFF

Chris Bruce, Director
Jeanne Fulfs, Education Coordinator
Boone Helm, Collections Manager/Preparator
Brenna Helm, Assistant Curator
Tonya Murray, Program Coordinator
Anna Maria Shannon, Assistant Director
Robert Snyder, Development Director
Keith Wells, Curator

WITH ASSISTANCE FROM

Chelsea Brinkerhoff
Prima Gonzalez
Gry Knudsen
Jason Lascu
Alma Rocha

FRIENDS OF THE MUSEUM OF ART BOARD

Jill Aesoph
Kathleen Bodley
Judy Busch
Paul Couture
Debra Dzuck
Susan Gill
Ashley Grosse
Linda Hartford
Fritz Hughes
Gary Lindsey
Gene Rosa
Chris Watts

MUSEUM OF ART DOCENTS

Karin Vercamer, Docent Coordinator
Jan Dombrowski
Sally Horton
Susan O'Lexey
Marion Park
H. Clare Wiser